MW01169971

IMAGES
of America

RICHMOND AREA

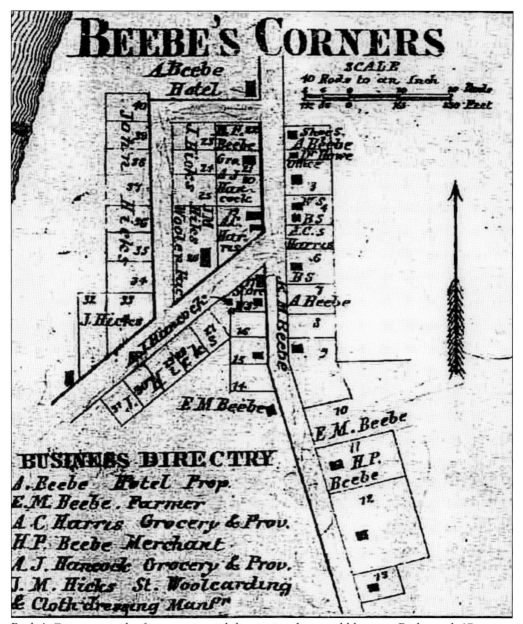

BEEBE'S CORNERS

A Beebe Hotel

SCALE
40 Rods to an Inch

BUSINESS DIRECTRY

A. Beebe Hotel Prop.
E. M. Beebe . Farmer
A C Harris Grocery & Prov.
H. P. Beebe Merchant .
A. J. Hancock Grocery & Prov.
J. M. Hicks St. Woolcarding
& Cloth dressing Manf'r

Beebe's Corners was the first commercial district in what would become Richmond. (Courtesy of Richmond Area Genealogical and Historical Society.)

IMAGES
of America

RICHMOND AREA

Lori Nye and Norman Gibson for the
Richmond Area Historical and Genealogical Society

ARCADIA
PUBLISHING

Published by Arcadia Publishing
Charleston, South Carolina

Printed in the United States of America

Library of Congress Control Number: 2012934128

For all general information, please contact Arcadia Publishing:
Telephone 843-853-2070
Fax 843-853-0044
E-mail sales@arcadiapublishing.com
For customer service and orders:
Toll-Free 1-888-313-2665

Visit us on the Internet at www.arcadiapublishing.com

*This book is dedicated to the Richmond Area Historical and
Genealogical Society and the Lois Wagner Memorial Library
for their continuing preservation of Richmond-area history.*

CONTENTS

ACKNOWLEDGMENTS

The authors would like to extend our grateful appreciation to the Richmond Area Historical and Genealogical Society for providing us with the images found in this book and for allowing us access to the *Richmond* Review, on CD-ROM and in paper format, for our use in compiling this book.

We also extend our gratitude and appreciation to the following organizations and persons for their assistance in providing photographs and information to the Richmond Area Historical and Genealogical Society collection, which were used in the preparation of this publication: Ursula Adamson, Vince Bruscea, Stuart Burleigh, Al and Jan Collins, Carrie and Loretta Dittman, Brian Egen, George Fealko, Pat Fenton, First United Methodist Church, Bill Foss, David and Susan Foster, Doris Fuerstenau, Dianne Gibson, Jeff Goodar, Marilyn Gravlin, Linne Haddock, Pat Hendrickson, Tina Kacanowski, Lois Wagner Memorial Library staff, Sharon Van Auken Lundsford, Patrick McClellan, Ann Summers McKennis, Tom McKiernan, Patti Papuga, Wes and Carole Pease, Dale Quick, Richmond Fire Department, Christine Rowley, St. Augustine Catholic Church, St. Peter's Evangelical Lutheran Church, Warren Schwark, Mary Ellen Shepherd-Logan, Mary Stewart, Jean Waterloo, Rich Weinert, and Ellyn Youatt.

INTRODUCTION

This visual history of Richmond, Michigan (located in the northeastern quadrant of Macomb County), is woven through time and the merging of several small communities to the expanded city that one sees today. Included photographs were carefully selected depicting the history of the area. Availability and quality of photographs affected the selection process. We have focused our selection on the earliest photographs available to us in illustrating a condensed history.

The first settler to the community, Daniel Hall was issued a land grant signed by Pres. Martin Van Buren. Hall cut the first road through the wilderness following an Indian trail from Gratiot Turnpike to his property, about two miles north, in order to get his team of oxen and wagon through the woods.

That same year two brothers, Erastus M. and Henry P. Beebe, traveled from New York State through Cleveland, eventually following an Indian trail east from Armada, Michigan, to its junction with a north-south Indian trail, now known as Memphis Ridge. Like Daniel Hall, the Beebe brothers also received land grants from the government that were signed by President Van Buren. They were not eager to farm the land, but to establish a settlement. At the juncture of the two Indian trails, Erastus laid out a plot for a town, sold some lots, and began building his own businesses and a name for himself. Later in 1835, Alexander Beebe, brother of Erastus and Henry, also moved to the area from New York State. He was a good carpenter and built many strong houses out of the timber in the area. This community became known as Beebe's Corners.

In 1859, Beebe's Corners had two significant rivals that were emerging. The first was the unincorporated settlement that became known as Cooper's Town, just south of Beebe's Corners, which was started by James W. Cooper, who was also originally from New York State. Cooper built a stave mill and cooper's shop, shipping some of these barrels to New York and Canada. He later added a hotel and two stores, attracting businesses and settlers to the area.

The other rival to Beebe's Corners was the community of Ridgeway, also known as Lenox, which was farther south on the ridgeline that became known as Main Street. This community really began to flourish when the Grand Trunk Railroad chose to put a depot there. Eventually the community of Ridgeway was renamed Lenox when they were informed by the postmaster general that the name was duplicated elsewhere in the state. Lenox grew to a bustling business community around the rail depot with hotels, sawmill, and other businesses.

The three communities became united in 1876 through the establishment of a community newspaper, the *Richmond Herald*. In 1879, the communities of Ridgeway (Lenox), Cooper's Town, and Beebe's Corners were incorporated into the Village of Richmond. Later in 1966, the Village of Richmond was incorporated as a Michigan home-rule city under the council/manager form of government.

A later addition to the community known as Muttonville, or East Lenox (also previously known as Wier's Corners), was annexed into the City of Richmond in 1989. Muttonville began as the location of St. Peter's Lutheran Church, built in 1863; a grocery store; and a saloon. It has been

said that it was so named because of the farmers bringing their sheep for loading on the railway that was there. This could not be true as there was not a depot there. Other accounts indicate that sheep were slaughtered there. Additional additions to the city of Richmond in 1998 were parts of Richmond Township and Casco and Columbus Townships.

Over the years there has been, what would appear to be, a natural growth of the communities towards each other until it has become a continuous community of what one sees today. The dreams and visions of Daniel Hall and Erastus and Henry Beebe—men who carved a life out of the virgin forest—appear to have come true with the modern and bustling Richmond area.

One

FOUNDING FAMILIES

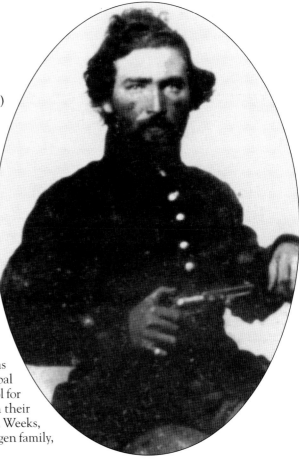

Pvt. Daniel Webster Hall (1838–1875) of Company G, 15th Regiment of the Michigan Infantry was the son of Daniel G. (1807–1880) and Sarah (Norton) Hall (1809–1886) of Beebe's Corners, Michigan. Private Hall was promoted to first sergeant on May 1, 1865, and honorably discharged at Little Rock, Arkansas, on August 13, 1865. Daniel G. Hall, originally of Connecticut, relocated to the Michigan Territory in 1835, when it was just a wilderness. He is attributed for breaking the path from Gratiot Turnpike, north on what is now known as Main Street, to his property just north of the current city of Richmond, where the Richmond Cemetery is now. The Hall family was active in forming the Methodist-Episcopal Church and establishing the first school for the Richmond area, which was held in their log cabin. The first teacher was Mahala Weeks, who taught six scholars. (Courtesy of Egen family, Monroe, Michigan.)

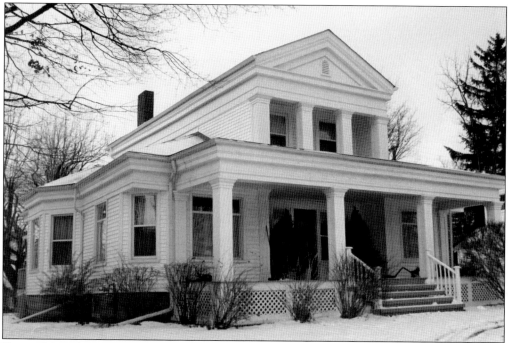

Erastus M. and Henry P. Beebe walked from Detroit to Mount Clemens and then on to Armada. Erastus and Henry worked their way through the wilderness along the Indian trail, a trail running east and west now known as the Armada Ridge, where it met the other ridge running north and south, now known as Memphis Ridge. Erastus owned the land where the village of Richmond now stands, laid out the plat of the town, and sold lots for $25 and up. Erastus was a blacksmith and a distiller by trade. The Beebe brothers received their land grant from Pres. Martin Van Buren. Erastus lived in this house located at 69725 Main Street, which may be the oldest residence in Richmond.

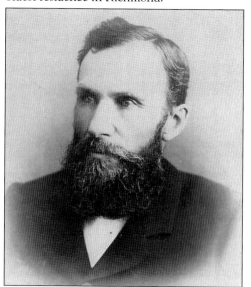

Porter Beebe (1843–1896) and Mary Beebe (1841–1899) are seen here. Porter was the son of Erastus M. and Sophronia (Ewell) Beebe.

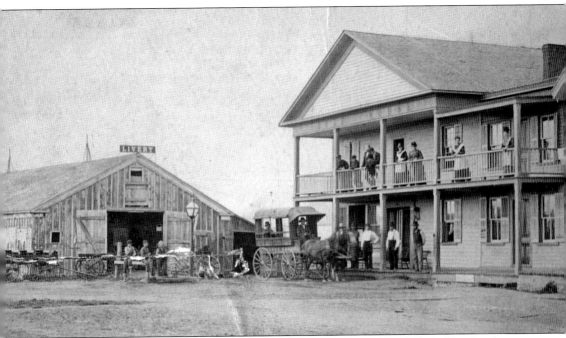

This c. 1860 photograph shows the Beebe House hotel. Alexander Beebe followed his brothers Erastus and Henry to Beebe's Corners in 1835. His wife was Priscilla Comstock. Sometime in 1847 or 1848, Alexander built Beebe House on the west side of Main Street at Madison Street. On the left is a livery and on the right is a photography shop. The carriage in front has "Beebe House" lettered on the side of it; presumably it was used to transport customers around the area. The hotel was moved across the street in 1864 or 1865.

A brick house, known as Fletcher's, stands where the Beebe House hotel once stood. Greenhouses were located in back. The floral business was owned and operated by J. Guy and Mabel Fletcher, their son Jack, and his wife, Lois. At one time it was the residence of Simon H. Heath and family.

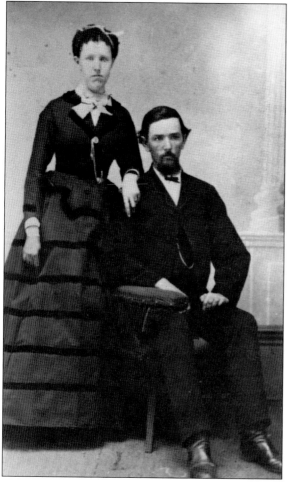

Simon Henry Heath (1840–1910) and Annis Ophelia (Beebe) Heath (1845–1933) were married on March 11, 1867. Annis was the daughter of Alexander Beebe. Simon, at the age of 21, came to Richmond from Hillsdale, Michigan, to clerk in the Pioneer Store, a general store and post office. Simon enlisted in Company H of the reorganized 4th Michigan Infantry, which mustered in on October 14, 1864, under Col. Jarius W. Hall at Adrian, Michigan.

Two

BEEBE'S CORNERS

The first general store was built on the northwest side of the Armada Ridge and Main Street intersection by Henry P. Beebe (1817–1891). It carried groceries, dry goods, shoes, and boots. When he was postmaster, this store also served as a post office. This area became known as Beebe's Corners. Henry P. Beebe married Ellen M. Norton, daughter of Jeremiah and Rachel Norton, in 1850. Sometime before 1886, George Boucher's saloon was located there. Today, there is a home, built in 1908 by George and Mary Boucher, at the location.

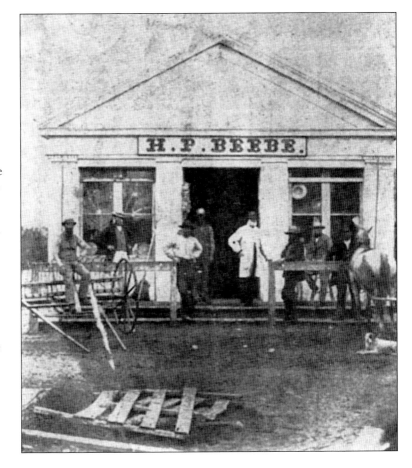

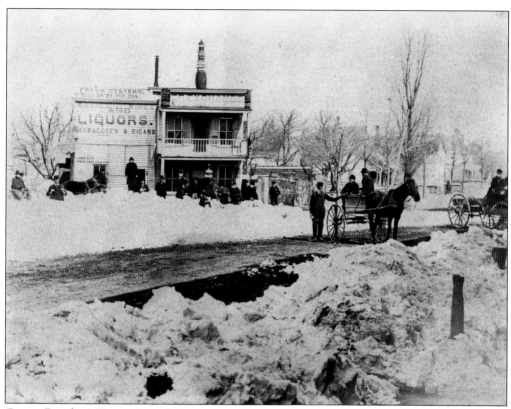

George Boucher's Tavern at Beebe's Corners, pictured here following the April 6, 1886, snowstorm, advertises fresh oysters by the can or in bulk, choice wine, liquors, tobaccos, cigars, and Stroh's beer on the outside of the store. On top of the store there are barrels stacked one on top of another with a bottle on top. This had been the location of H.P. Beebe's general store. There was a town meeting scheduled regarding snow cleanup, and the residents worked hard at clearing the streets.

In 1908, George and Mary Boucher built their home on the site shown in this 1990 photograph.

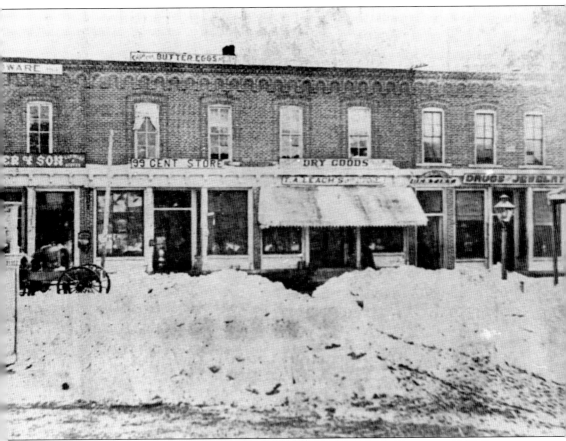

At Beebe's Corners there was a commercial block built by Dr. Daniel Gleason in 1869. Seen in this photograph are W.O. Fuller and Son Hardware, 99 Cent Store, T.A. Leach's Dry Goods, and Dr. Gleason's Drug Store on the right. The April 6, 1886, snowstorm was labeled as "The Biggest Snowstorm ever to strike Michigan." It left in its wake snow levels of 10 to 40 inches throughout southeastern Michigan. It was accompanied by winds of at least 32 miles per hour, low temperatures ranging between 20 to 30 degrees, and visibility of less than 500 feet. A major fire destroyed this block, and the area was rebuilt as residences.

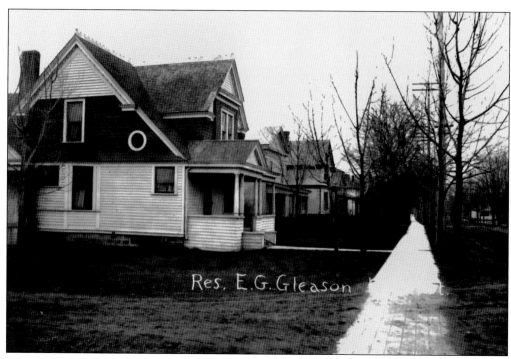

Res. E.G. Gleason

Pictured above is the home of Elmer Gleason, son of Dr. Daniel Gleason, pictured at left. Dr. Gleason and his wife, Lucretia Mathews, moved their family to Beebe's Corners in 1865, where he bought land and in 1869 built the first brick commercial block in the village. Dr. Gleason was a state representative; owned a general store, blacksmith shop, and livery stable; and had one-third interest in the Richmond Cheese Factory located on Main Street near Pound Road. His son Elmer operated the drugstore at Beebe's Corners until the business moved to Cooper's Town.

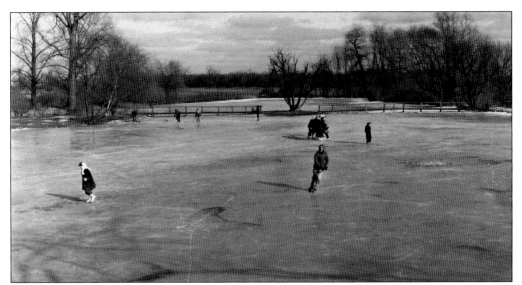

Ray Swift Pond is on the east side of Main Street just north of Pound Road. In the 1950s, this was the place to be to ice skate. At times on the weekend or during Christmas break there might be a hundred or more young people skating here. The other end of the pond was used for hockey.

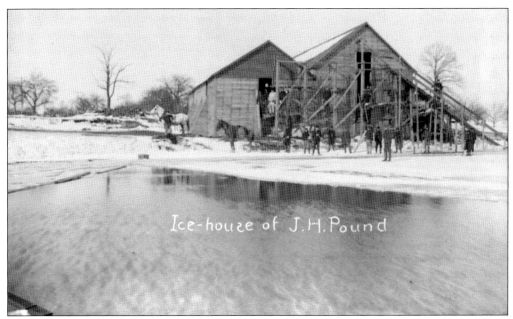

Ice-house of J.H. Pound

J.H. Pound Ice House was located on the same pond in earlier years. Blocks of ice were cut from this pond during the winter and used by businesses and homes in the community. One business that needed ice was the Weter, Fanning & Company that processed butter and eggs. These buildings were torn down in the 1930s.

The Hillside Dairy Farm was located on North Main Street across from the Pound Road intersection. Joseph Winkle and his wife, Delia Laude Winkle, moved to this farm in March 1904 and took over the village milk route the following month, running it until 1910. In September 1910, he became the president and general manager of Farmers' Elevator and held that position until he died on July 4, 1929. Late in 1948, the Veterans of Foreign Wars post purchased the old Almstadt farm residence on the Hillside Dairy Farm. This home, shown below, was converted into a comfortable clubhouse, called the VFW Outpost. A few years later, the post sold this clubhouse and moved into the Don Jose building on North Forest Avenue. The house was torn down in 1966.

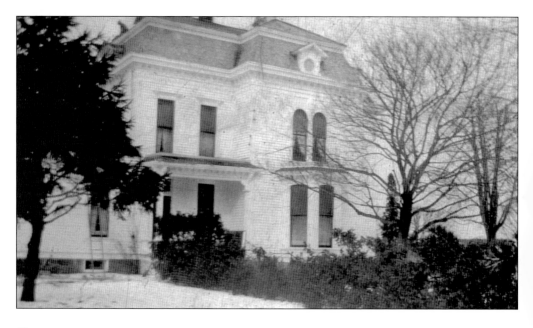

Three

COOPER'S TOWN

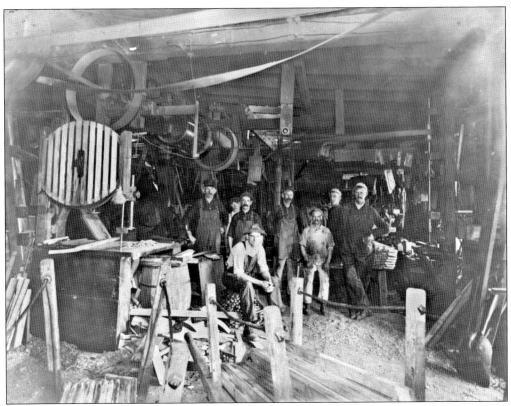

Cooper's Town ran along Main Street from Park to Forest Streets and a short distance east and west on Division Road. Cooper's Stave Mill was located on the east side of Main Street south of Division Road. A large number of men were employed to make barrel staves out of elm and black ash. The mill employed a large number of men and burned twice. James W. Cooper used his profits to build a hotel and stores.

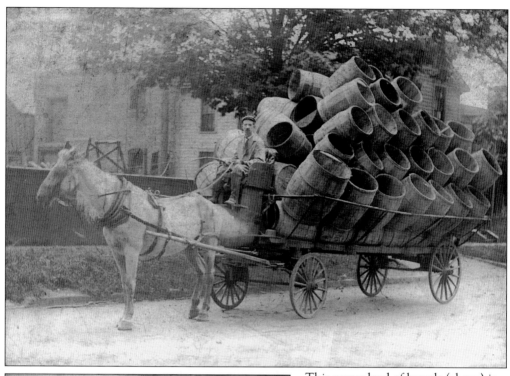

This wagonload of barrels (above) is being driven by John W. McMann (1850–1933), pictured at left. Barrel making was a very important industry contributing to the growth of Richmond. Barrels were used to pack a variety of grocery products and even dinnerware. McMann had a cooper shop at the corner of Main Street and Division Road in which he put the staves together to make the barrels. A business across the road used his barrels to pack choice apples for shipment in them. Weter, Fanning & Company probably used his barrels to ship eggs.

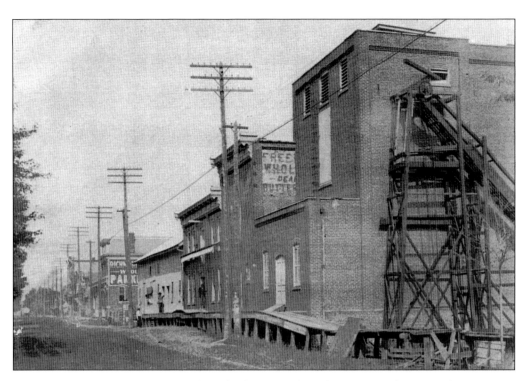

Weter, Fanning & Company purchased a butter and egg business in the 1880s from Harrop Freeman, who started the business in 1872. In 10 years, the business grew from 600–700 barrels to 3,000–4000 barrels of eggs and 250,000 pounds of butter annually. Twenty-five people were employed in these buildings that were located on the east side of Main Street, north of Division Road. In the image below, the man on the far right is James E. Weter, second from right is Frank Fanning, seated on the right is Thomas Fanning, and the girl next to him is Rena Fanning.

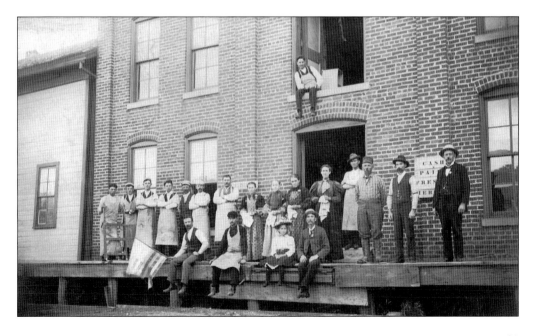

The men seated are dressed in Weter, Fanning & Company uniforms. From left to right are (first row) Will Trost, unidentified, Charles Sutton, Frank Fanning, and Charles Heath; (second row) Otto Huwe, Thomas Fanning, and Albert Kludt.

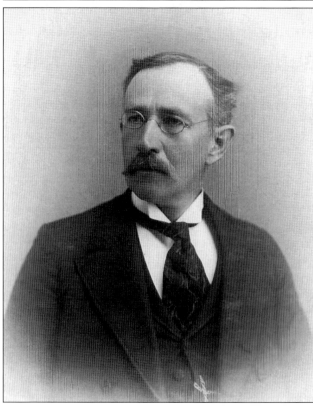

Martin Keeler (1848–1883) was born to John and Marie (Fellows) Keeler of Schoharie County, New York. His parents originally settled in Washington Township, Macomb County, in 1826. In 1850, they sold their farm and relocated to Disco, Michigan. Martin was one of the original members of the Disco Christian Union. He married Flora Annette Preston in 1871. Martin was a partner for a time in the Weter, Fanning & Company.

Thomas Fanning (1852–1927) began his career at Freeman's as a foreman before purchasing a business. He went into partnership with James E. Weter and Martin Keeler, and the business was renamed the Weter-Fanning Company. Thomas married Arabelle Freeman, widow of his previous supervisor, Harrop Freeman, on May 4, 1887. Arabelle was the sister of his current partner, James E. Weter. They had one child, Rena Bell. Their home was situated opposite the plant.

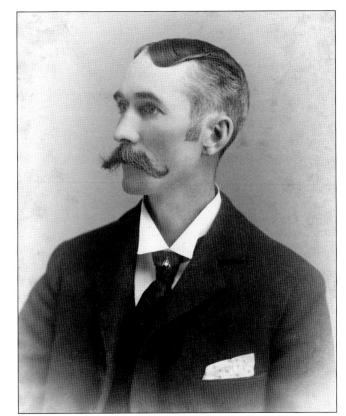

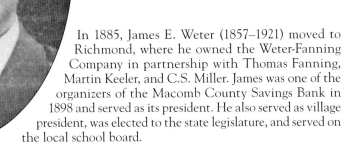

In 1885, James E. Weter (1857–1921) moved to Richmond, where he owned the Weter-Fanning Company in partnership with Thomas Fanning, Martin Keeler, and C.S. Miller. James was one of the organizers of the Macomb County Savings Bank in 1898 and served as its president. He also served as village president, was elected to the state legislature, and served on the local school board.

23

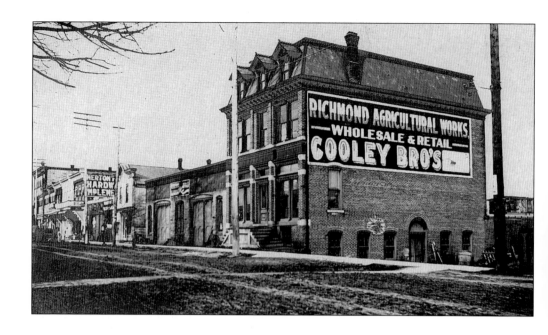

Above is a c. 1900 photograph of the Cooley Brothers Company, located on the northeast corner of Main and Water Streets. They produced agricultural equipment in a foundry located behind the building. After Myron Cooley died, his brother Frank and Richmond banker William H. Acker convinced John Parker to move his Parker Plow Company from Vassar, Michigan, into this facility. Below, the Cooley Brothers building can be seen at the other end of the block from the Commercial House, located on Main and Monroe Streets. The Commercial House was sold in January 1913 to William Elliott for $9,000. It was extensively remodeled and renamed the Elliott House.

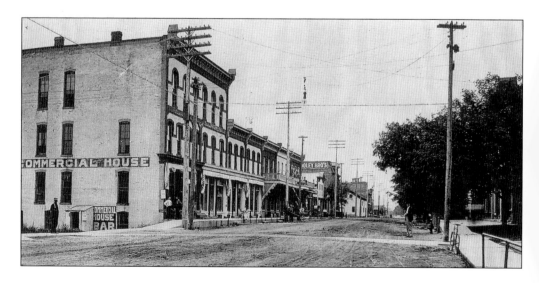

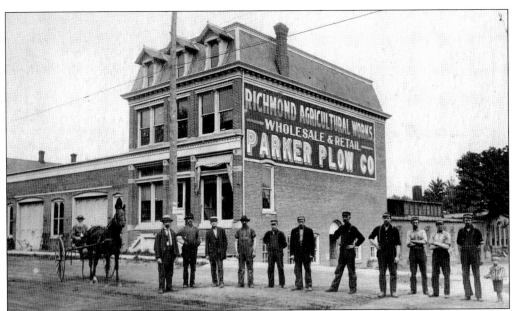

Parker Plow Company employees line up in the intersection of Main and Water Streets to have their photograph taken. The third man standing from the left appears to be John Parker. The company was started in 1884 in Vassar, Michigan, by John Parker. The business moved to Richmond in 1907. The company produced plows, bobsleds, bean harvesters, Soil Krushers, and other products made of cast iron or that had cast iron parts. The foundry was located behind the three-story building. The company acquired other plow manufacturers and sold its products from Minnesota to Maine and south into Ohio and Illinois. John Parker (1859–1947), pictured at right, was the founder of the Parker Plow Company. He married Elizabeth McCreedy in the fall of 1883, and they had five children.

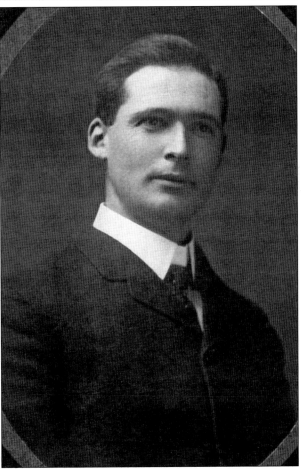

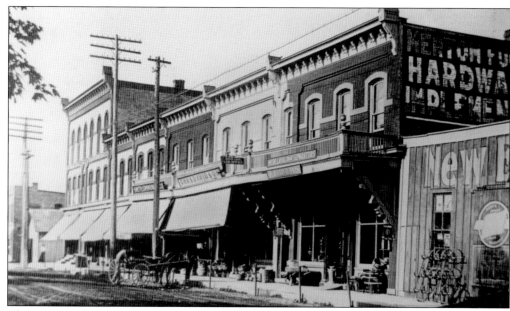

The c. 1908 photograph above looks north toward the three-story Commercial House hotel located on the southeast corner of Main and Monroe Streets. Starting on the left and moving to the right are the Smith & Simmons Company, Charles Davidson's business, a business that sold cream separators and hardware, and a store selling New Era farm equipment. The Cooper and Son Department Store occupied the next two storefronts before the hotel. The image below shows people gathered on a winter day in front of the Cooper and Son store for a prize drawing.

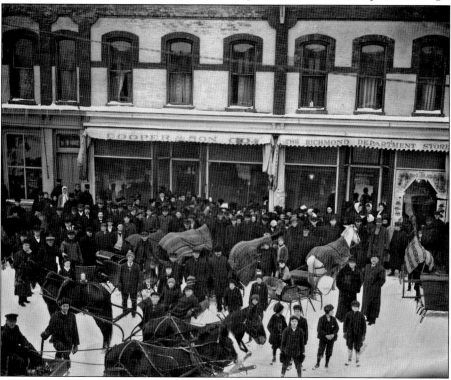

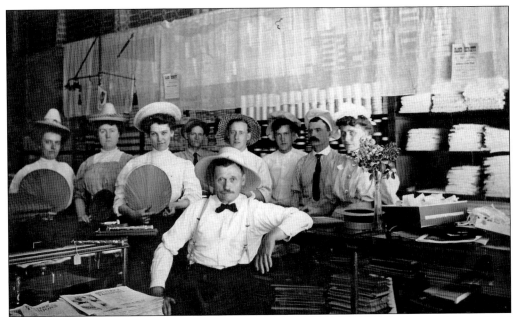

The Cooper and Son Department Store clerks are showing off the latest in hats and fans. Could the man in front be James W. Cooper, or his son James P. Cooper?

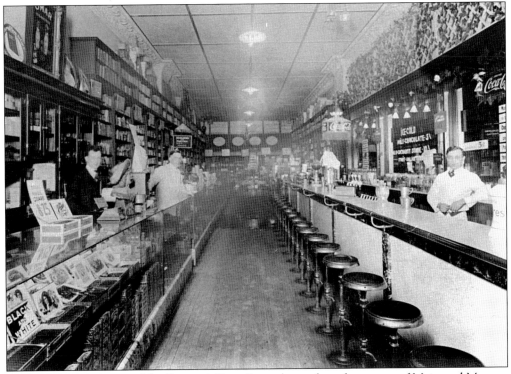

This is an interior view of the Denton's Drug Store, located on the corner of Main and Monroe Streets. Ed Denton purchased the business from Grace Griffin, who had bought it from John Lutz. He remodeled the store about 1939 with a new tile floor and soda fountain. Denton had worked for Lutz prior to getting his pharmacy license.

On the right above is the Ed Dixon Livery Stable located on the corner of Main and Monroe Streets. The next building was the Richmond Post Office, followed by Miller's Pool Room, Puls' Barber Shop, a grocery store, review office, and Tedman's Meat Market. The livery stable building was sold and became Lutes Brothers Buick-Chevrolet. The First National Bank was built on this site in 1946. Notice the string of lightbulbs used to light the intersection and the concrete walk across the unpaved street in this 1906 photograph. Pictured below is the same street scene.

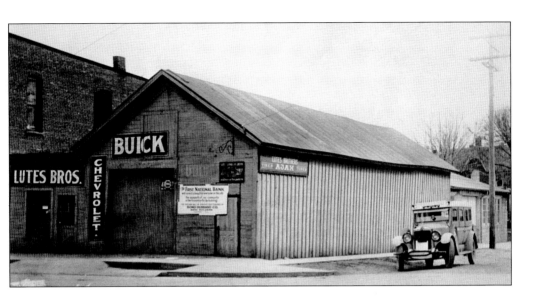

Lutes Brothers Buick-Chevrolet (above) was located at the site of the former Ed Dixon Livery Stable on the northeast corner of Main and Monroe Streets. The vehicle seen here had emergency lights and was either a police car or ambulance. The white sign board announced that a new First National Bank, shown below, would be built on this site. The new bank building was completed in 1927. The building housing the Richmond Post Office on the bank's right was torn down later to make way for an addition. Professional offices were located on the second floor.

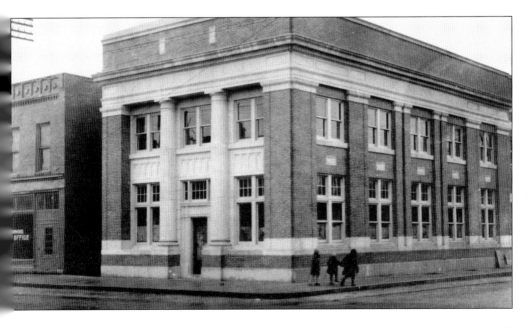

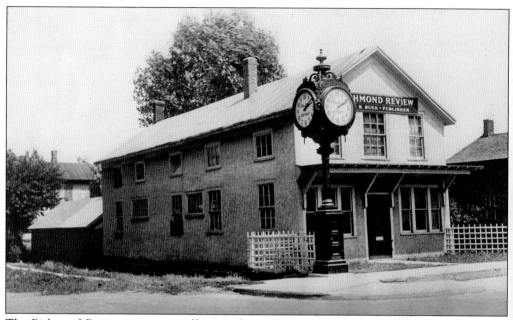

The *Richmond Review* newspaper office was located on the southeast corner of Main and Park Streets. The *Richmond Review* was first published June 8, 1876, as the *Richmond Herald* by Del T. Sutton and George W. Kenfield. Then William C. Walters published the first *Richmond Review* on November 8, 1877. The *Review* was published in several buildings before moving to this one sometime between 1915 and 1920. The publishing company moved from this building in June 1958. The last *Richmond Review* was published on February 27, 2000.

Gilbert E. "Square Deal" Miller (1876–1949) was the son of Albert and Elizabeth (Smith) Miller, who moved to Richmond in 1850. His grandfather and father owned a foundry, gristmill, and sawmill on Armada Ridge Road. Gilbert was a participating member of the Cornet Band, which he directed at one time. He was married to Maude Yeaton, also a Richmond native. He donated the town clock, shown in the image above.

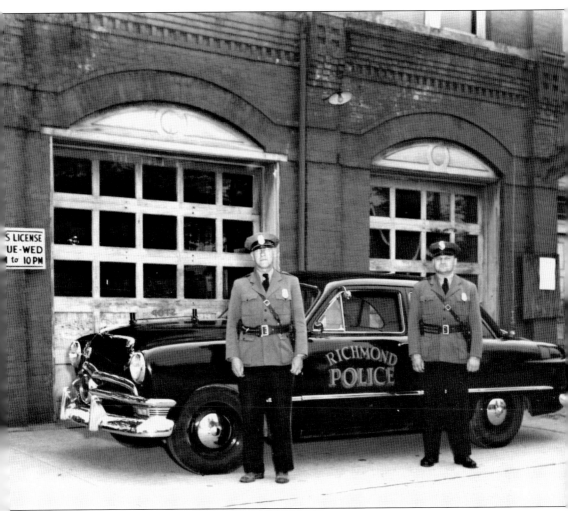

In this c. 1950 photograph, Scott Burke **(left)** and Norman Bobcean are shown in front of the Richmond Municipal Building, erected in 1884 on the northwest side of Park and Main Streets. This building housed the village offices and fire and police departments. Francis Scott (F. Scott) Burke (1895–1984) served in numerous civic offices, working as a police chief for Richmond, probation officer for Macomb County, sheriff for Macomb County from 1947 to 1948, mayor, city councilman, president of the board of education, and justice of the peace. He married Agnes M. Corbat in 1917. They had one son, Robert, who was killed in World War II. The Sullivan-Burke American Legion Post 125 was partially named in honor of his son. Norman Bobcean (1923–2009) served as an officer on the Richmond Police Department and retired from the Macomb County Sheriff's Department in 1985. He also was the football and baseball coach and driver's education teacher for St. Augustine High School.

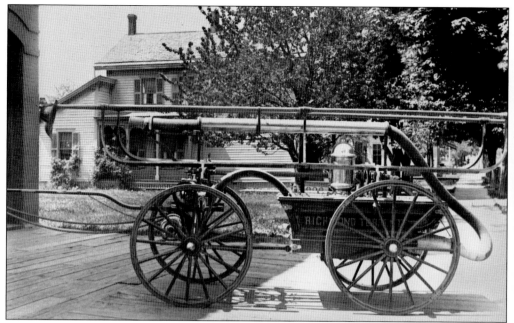

This c. 1900 photograph was taken looking north from in front of the fire hall. The fire apparatus was a hand-drawn and hand-operated piece of equipment. Jeffers & Company of Pawtucket, Rhode Island, was manufacturing this type of pumper in 1863.

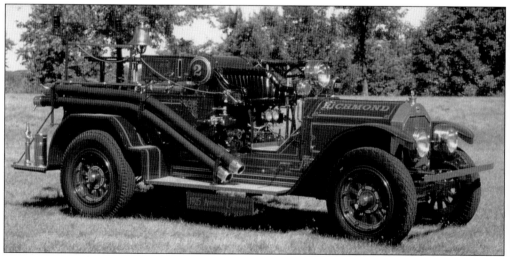

When the Richmond Lumber Company & Mill, formerly the Weston Planing Mill, burned on March 19, 1925, a company selling fire trucks happened to be in town and helped put out the fire. Because of this, the village purchased this 1925 American LaFrance fire truck from them. The reduction in fire insurance premiums more than offset the increase in property taxes needed to pay for the truck.

The Weston Planing Mill was located at 36040 Division Road, just east of North Forest Street. This company was started in April 1875 by the Weston brothers, George and Holmes. Holmes sold his interest in the company to Daniel L. Rapelje in the early 1880s. In 1910, George Weston (below left) and his son Winfred J. (below right) took over the business. The company rebuilt after the 1925 fire but ceased milling operations and just sold lumber and building materials. This view looks southwest towards homes on Main and Forest Streets. Running behind the stacks of lumber is a railroad siding, which would have been essential for shipping lumber. This business became Richmond Lumber Company and later Meade's Lumber.

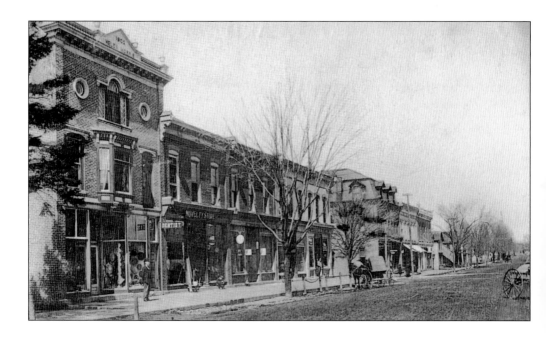

The Helen Morris Building, above left, was constructed in 1902. The first floor was a millinery store, and the doorway on the right corner of the building was to a dentist office on the second floor. The next building north was Skinner's Novelty Store. The large structure across the intersection of Monroe and Main Streets was the Masonic building. The photograph below shows a view looking south from Monroe Street of the storefronts, starting with Lutes Drug Store. To the left of the drugstore is Flack's Bakery, with a very large cake displayed in the window. It is interesting to note concrete sidewalks with gravel streets and a fire hydrant at the corner.

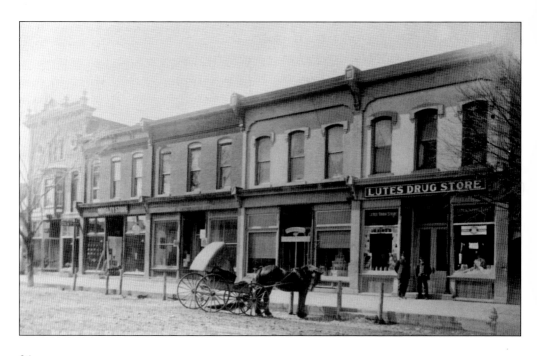

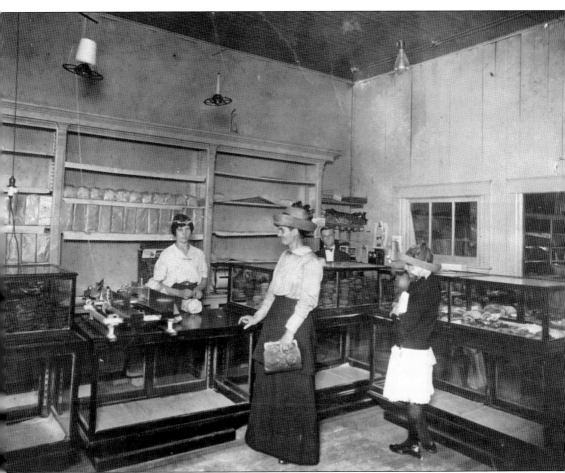

Charles Flack's Bakery was located on Main Street just south of Monroe Street, next to Lutes Drug Store. The loaves of bread were wrapped in brown paper and tied with string from ceiling dispensers. There were cookies stacked high in the glass cases on either side of the women. There was a wooden case wall phone in the back corner and a horseshoe over the door. In 1915, a confectionery and ice cream parlor were added on. This part of the business was managed by Myrtle Johns.

In 1936, there was a Borden's Creamery located at the southeast corner of Division Road and Main Street. The 1939 photograph below shows a milk can conveyor system that made moving cans in and out of the building easier. Another business processing milk from the numerous dairy farms in the area was the Richmond Dairy. Gustav A. Schultz bought the Richmond Dairy business from his brother Frederick Schultz in 1924. In 1947, he took his two sons, William and George, in as partners. That same year, they bought out the Ray Houston Dairy and moved the location of the Richmond Dairy to the corner of Oak and Priestap Streets.

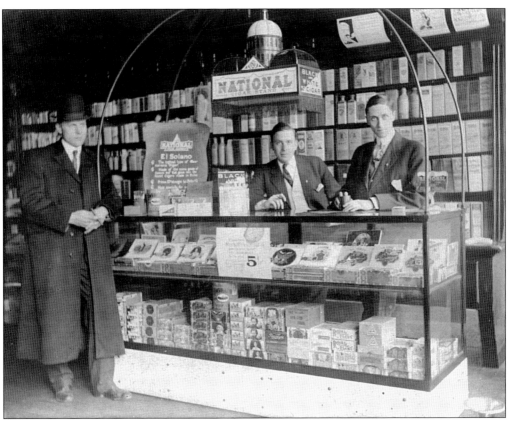

The Gleason Drug Store was located on the west side of Main Street between Park and Monroe Streets. It was operated by Elmer Gleason (right) and his son Harry (center) until Elmer died in 1915. Harry sold the business and moved to Detroit in 1918. This shop location can be seen in the photograph below where the apothecary sign is on the right side of the street. The men in the street were gathered outside of Puls' Barber Shop.

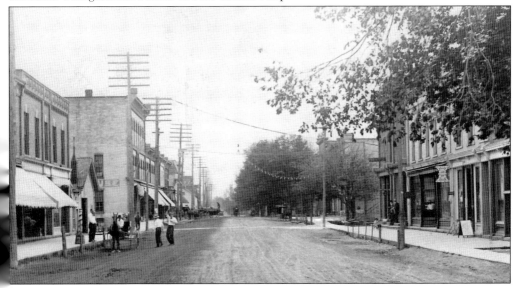

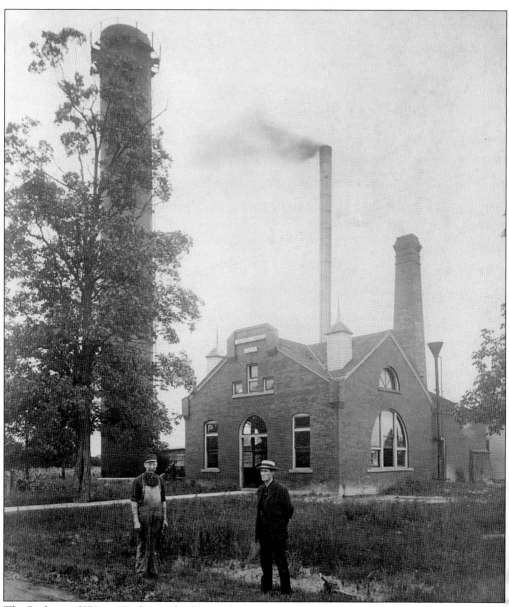

The Richmond Water Works was built in 1885 on the southeast corner of Water and Stone Streets. About five miles of water pipe was laid to supply water from artesian wells. This building also housed a steam-driven electric generator that supplied electricity for a few hours each day in the morning and evening. In later years, this building housed the police department and city offices. The building was torn down in 1987. The water tower on the left did not have a tank on top of it like water towers today. The man on the left is Charles Foss; the other is unidentified.

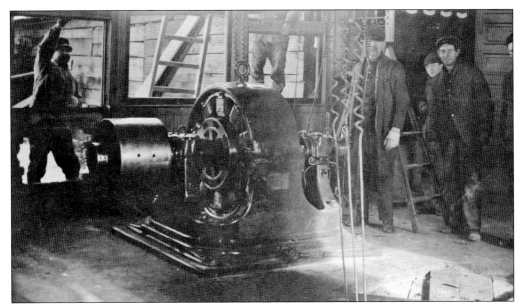

A new generator was installed in the water works building following the explosion of the old generator in 1911. Charles Foss is just to the right of the generator; the other men are unidentified. The village had installed their own electric system in 1900. Electric service was only available for a few hours in the morning and evening each day. Twenty-four hour service was provided by Detroit Edison in 1921 when they started providing electricity to the village. Electricity was not available to the farms outside the village until later. The first Edison office in the village was located in the south half of the Van and Sample's Grocery Store building located on Main Street between Monroe and Park Streets. This office was managed by Frank Burke.

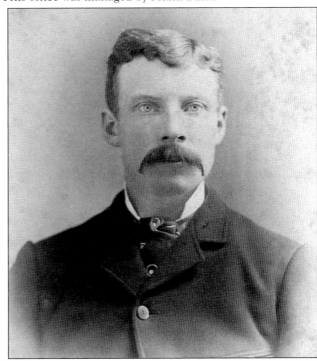

Charles Foss (1853–1927) relocated to Michigan from New York State as a young child with his parents, John and Sophia (Ellis) Foss. He married Henrietta Brinker in 1888. Charles worked many years for Priestap's Mill, the Village of Richmond, and later for Detroit Edison.

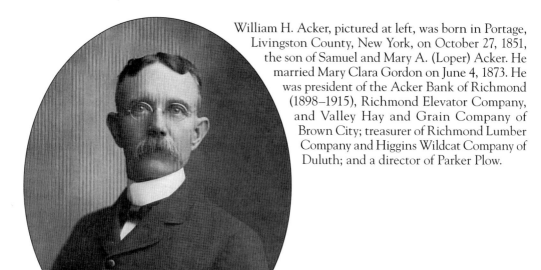

William H. Acker, pictured at left, was born in Portage, Livingston County, New York, on October 27, 1851, the son of Samuel and Mary A. (Loper) Acker. He married Mary Clara Gordon on June 4, 1873. He was president of the Acker Bank of Richmond (1898–1915), Richmond Elevator Company, and Valley Hay and Grain Company of Brown City; treasurer of Richmond Lumber Company and Higgins Wildcat Company of Duluth; and a director of Parker Plow.

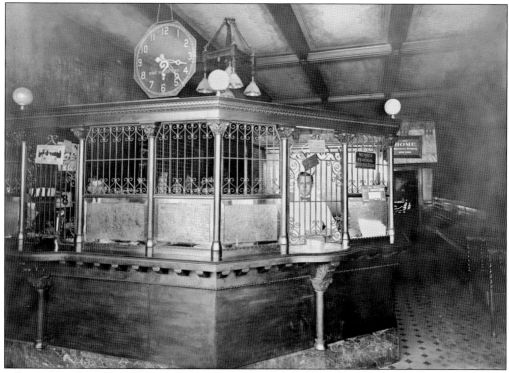

Albert F. Lindke (1886–1972), seen above, was the organizer of the National Bank of Richmond. He served as bank president from 1947, and following his partial retirement, he served on the bank's board of directors. He married Rena Fanning in 1913. Albert F. Lindke is pictured above as a cashier in the Acker Bank of Richmond.

The Rix Barber Shop was located on the west side of Main Street, just north of Monroe Street and next to the Masonic hall in what had first been the Acker Bank of Richmond and then the First National Bank. Seen above are, from left to right, Frank Puls (village of Richmond president, 1951), Leroy Rix, and John Dickinson. Leroy Rix, a World War II veteran, bought this barbershop from Murray Williams in December 1945. Williams had bought the business from Frank Puls in 1943. Puls had operated at this location since 1927, when the First National Bank moved out of this structure and into a new bank building across the street. The barbershop was in the building with the awning.

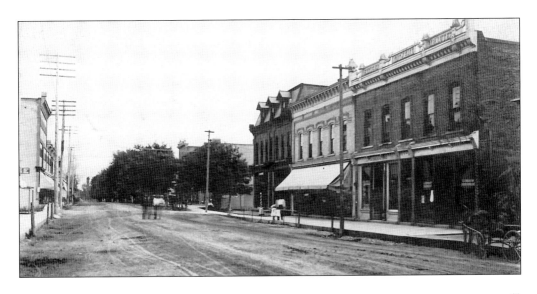

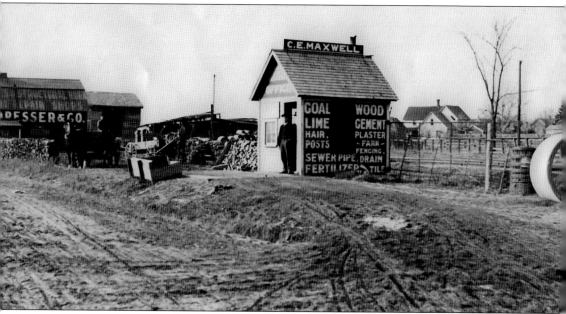

C.E. Maxwell's Coal Yard was located on the north side of Division Road, just west of Main Street. A railroad spur ran into the yard from the main line that ran behind this business. That track has been removed, and the right-of-way is now the Macomb Orchard Trail. Advertised on the side of the office are the following products: coal, lime, wood, cement, posts, farm fencing, drain tile, plaster, sewer pipe, and fertilizer.

Four

RIDGEWAY/LENOX

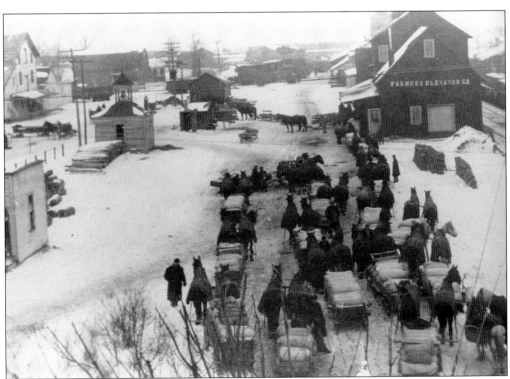

This c. 1910 photograph was taken from across Main Street showing farmers delivering grain to the Farmers' Elevator located across from the Grand Trunk Railroad Depot. In the left foreground is the Beatty Monument Shop with a fire station behind it. The Priestap Lumber Company is located upper left on Beech Street. The Farmers' Elevator and railroad depot were extremely important to the economic growth of the community. This part of town was also known as Ridgeway, then Lenox, and later Richmond.

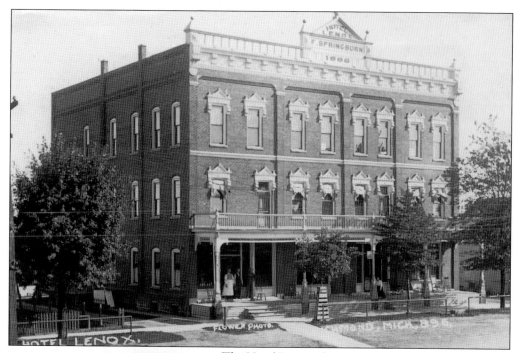

The Hotel Lenox, above, was built in 1886 by Ferdinand "Fred" Springborn (1851–1939), seen at left. He was raised in Marine City, relocated to the Richmond area as a young man, and was initially engaged in the restaurant business. The hotel was located on Grand Trunk Avenue across the street from the train depot. This was convenient for train passengers who needed a place to stay when visiting. The sign above the door advertises meals for 35¢. The hotel was acquired by the Knights of Columbus about 10 years before it burned in July 1939, after a dance that was held in the third-floor ballroom.

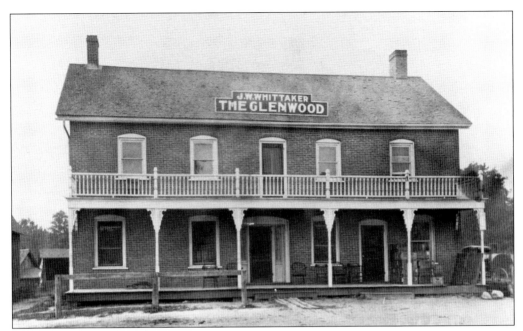

The Glenwood was built by J.W. Whittaker on Beech Street, and operated as a hotel and tavern. Stacked on the porch are about 20 wooden boxes labeled Goebel. The Goebel Beer Company was established in Detroit in 1873. This beer probably arrived by train at the depot located across the tracks from this establishment. It became the Cook Hotel when Charles Cook (1864–1929) and Eunice E. (Chambers) Cook (1871–1930), shown in the c. 1919 photograph at right, acquired it in 1915. They remodeled it in 1925 with a new heating plant and refurbished rooms and changed the office into a cafeteria. Eunice supervised the kitchen, which produced fine food. Following their deaths, the hotel was sold at an estate sale in 1936 to John and Julia Tincoff, who operated it for many years.

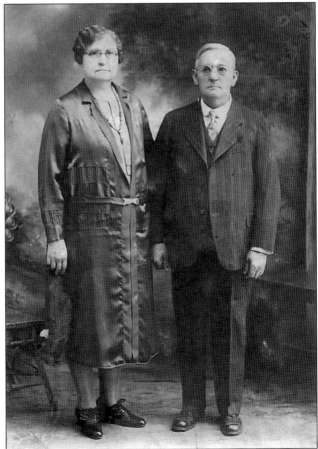

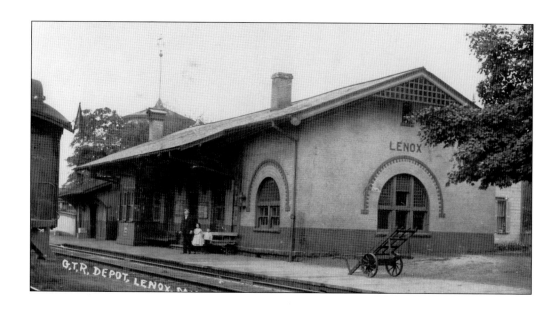

The Grand Trunk Railroad Depot was located in Ridgeway on Grand Trunk Avenue. This part of town was also known as Lenox and later Richmond. By 1859, the railroad running through Ridgeway connected Port Huron and Detroit. Ten years later, a rail line was opened between Ridgeway and Romeo. By 1884, the line had been extended to Jackson. These connections allowed merchants and farmers to make and receive shipments from all over the country and Canada. In those days, anything that was going to be shipped any distance was done so by train. In the photograph below, the Farmers' Elevator is on the left, the Lenox Hotel is on the right, and the depot is between them.

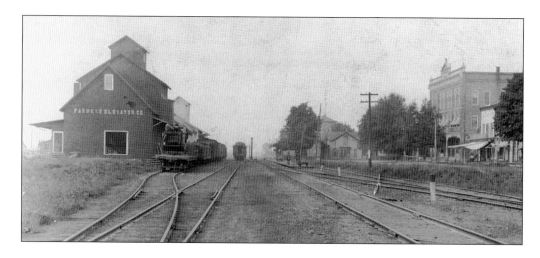

Fitzgerald's Grocery, above, was located between Grand Trunk Avenue and Birch (Lane) Street on Main Street. To the right is Chaskey's Meat Market, Elsa Kaufman's Dry Goods Store, and the beginning of the residential community in Ridgeway/Lenox. About 1914, D.L. Fitzgerald and Joseph W. Winkel became partners in Fitzgerald & Winkel, and later Winkel bought out Fitzgerald. The 1940s photograph below shows the interior of Winkel's Grocery Store. Grocery staples of bread, fruit, vegetables, and assorted types of canned goods line the shelves and baskets. Later, Vincent "Perry" Winkel, Joseph's son, owned and operated it. Pictured in the photograph below are, from right to left, Vincent Winkel, Joseph E. Winkel, and two unidentified clerks. Winkels operated the grocery for about 67 years.

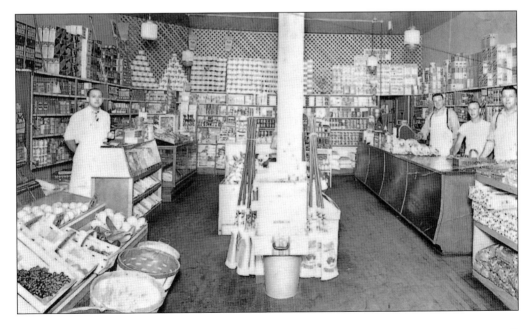

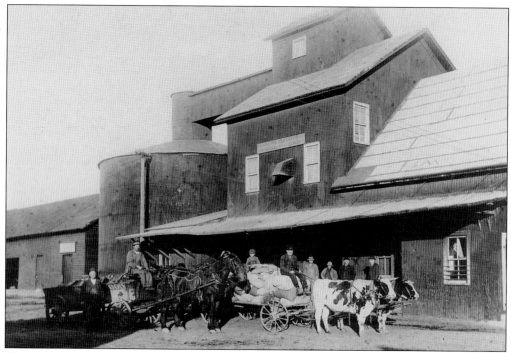

This 1902 photograph of the Richmond Elevator on Beech Street shows Jake Schweiger's oxen team with a load of grain. To the left is Cyril Hicks with a load of coal ready to deliver to a customer. The elevator was extremely important to the economic life of the community.

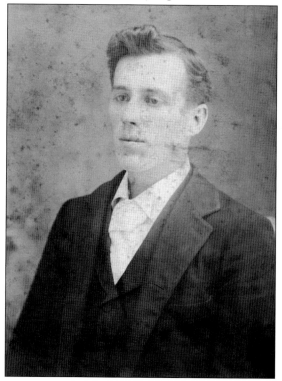

Cyril Hicks Jr. (1876–1954) was born to Mary Ann (Overton) Hicks six months after his father died. Hicks was a lifelong resident of the Richmond area, serving for 10 years as a police officer and 20 years as the water commissioner, retiring from the latter position in 1951. He was married to Nettie Gregg in 1896, and they had four children.

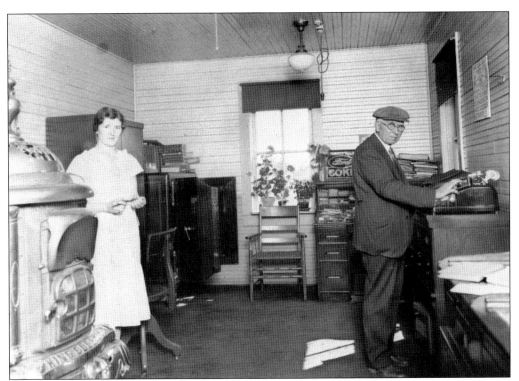

Mildred Maedel and Ed Rowley are photographed in the Farmers' Elevator company office on Beech Street. This is where area farmers brought their crops for shipment. The August 28, 1925, *Richmond Review* reported a robbery attempt. "Burglars, presumably the same gang that broke into the Donovan garage some weeks ago, made an unsuccessful attempt to robe the safe of the Farmers' Elevator Company office early Saturday morning [August 22, 1925] but were frightened away after wrecking the outer safe door. Several bags of beans had been piled on the safe to deaden the sound of the explosion. The charge had been placed too low to be effective and when it went off the beans were scattered all over and pieces of the huge steel door shot in various directions, one piece penetrating the ceiling perhaps a dozen or more feet away."

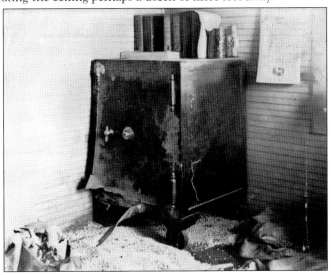

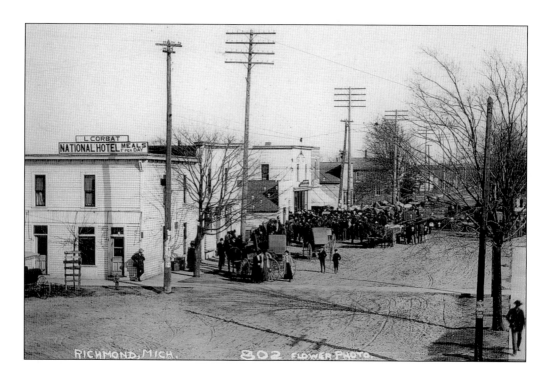

The National Hotel was bought by Louis Corbat in 1889. It was located on the corner of Grand Trunk Avenue and Main Street. At the time this photograph was taken, meals at the hotel were $1 per day. This part of town was known as Ridgeway and later Lenox. The crowd is gathered in front of a business for a raffle or sale. The National Hotel became Corbat's Bar, as seen in the 1940s photograph below. This building was destroyed by fire in the late 1960s.

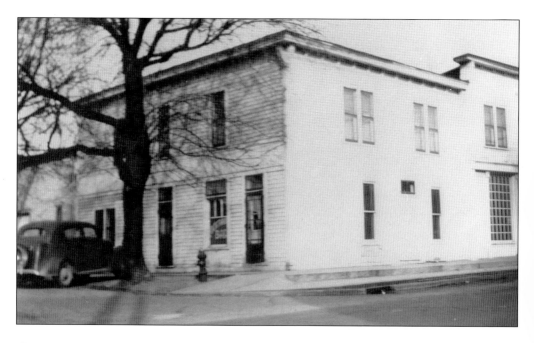

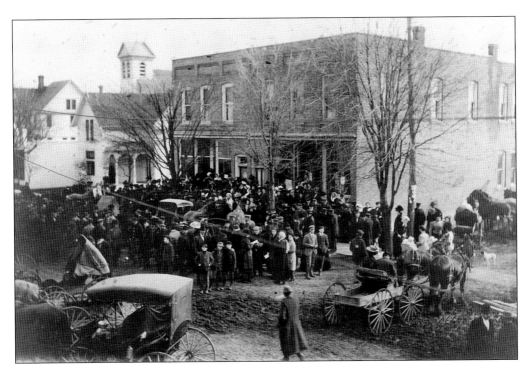

The c. 1915 photograph above was taken at Main and Gleason Streets. Richmond residents are gathered for a raffle promoting a local business. Many of the people seem to be looking at the photographer. In the background is the belfry of the first St. Augustine Church, which had been moved to that location to make way for the construction of their new church. Next door was the home of Mabel Winkel. In the photograph below, the steeple of the first St. Augustine Catholic Church can be seen at the corner of Howard and Main Streets.

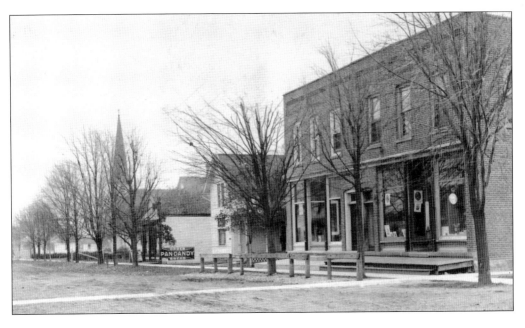

The 1940s photograph above shows a filling station advertising Staroline gasoline, which came from the White Star Refining Company in Detroit, Michigan. That company also made Staroleum Motor Oil. The street scene below shows Main Street looking south towards the St. Augustine Catholic Church with the filling station on the left. There are no crossing guards at the railroad crossing in this 1930s photograph.

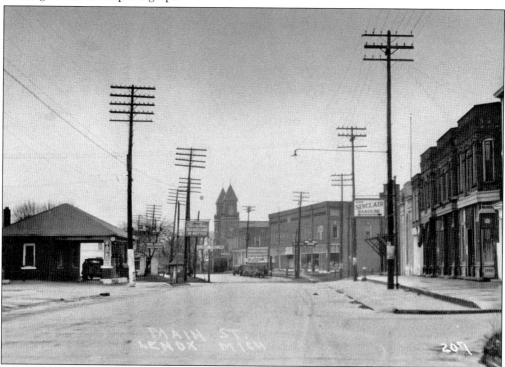

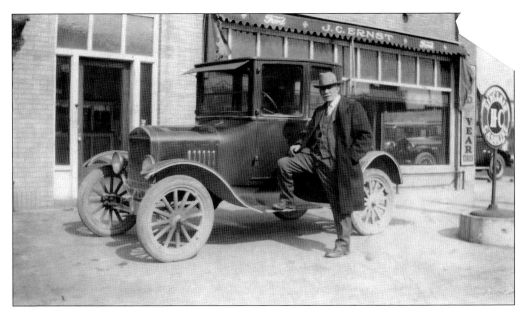

Osman B. Evans's parents settled in the Richmond community over 150 years ago. Osman B. Evans (1859–1948), shown by his automobile in front of the J.C. Ernst Ford dealership above, served as village president for Richmond for 25 years, from 1905 to 1930, and also served on the school board. During his tenure, he helped to shape Richmond's destiny and was often referred to as Richmond's walking encyclopedia. He married the former May A. Chubb, seated in a buggy in the photograph below, in 1892.

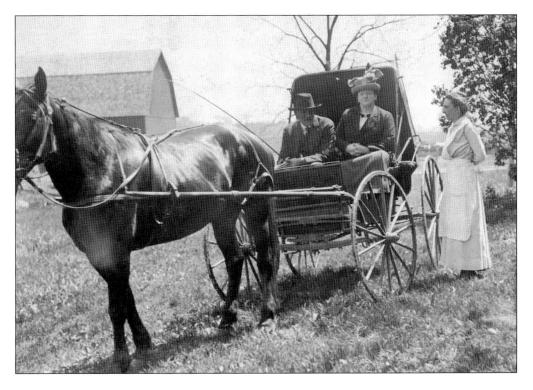

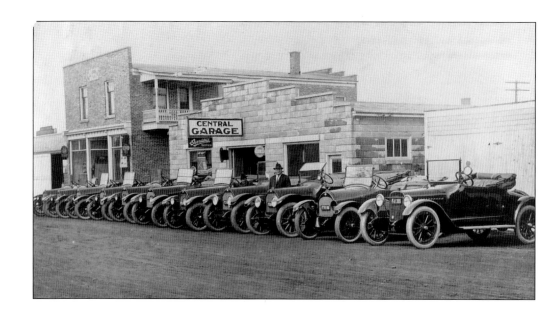

This c. 1920 photograph above shows the Central Garage owned by Schneider and Thueme that was located on the north side of Gleason Street behind the Gierk Block. It was an Overland car dealership and service center. The Overland car was built from 1908 to 1926. This building, along with the one on the right, was torn down to make way for a parking lot. Below is an earlier photograph that shows the Columbus Wagons business that handled Wiard's Plows and International Harvester machines. The brick building was constructed in 1914 by M. Fitzgerald. This building became a filling station and later Rickerts Auto Glass.

William Beauvais's Blacksmith Shop, above, was located on the south side of Gleason Street at the back of a lot about 100 feet from Main Street. William was the son of Peter and Ceserine Beauvais of Anchorville, Michigan. In 1898, he relocated to the Richmond area at the age of 16, initially being placed as an apprentice with Joe Bauman, a blacksmith in Muttonville. Upon completing his apprenticeship, he moved to River Rouge but moved back shortly afterwards, purchasing his shop on Gleason Street from Paul Puls in 1903. The building was eventually torn down in 1971. William Beauvais, seen at right at work in his blacksmith shop, is fondly remembered as Richmond's last blacksmith.

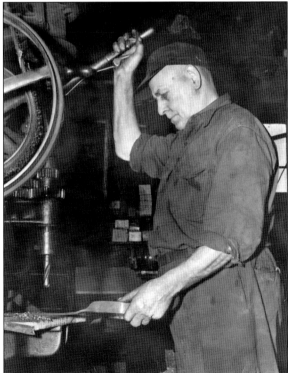

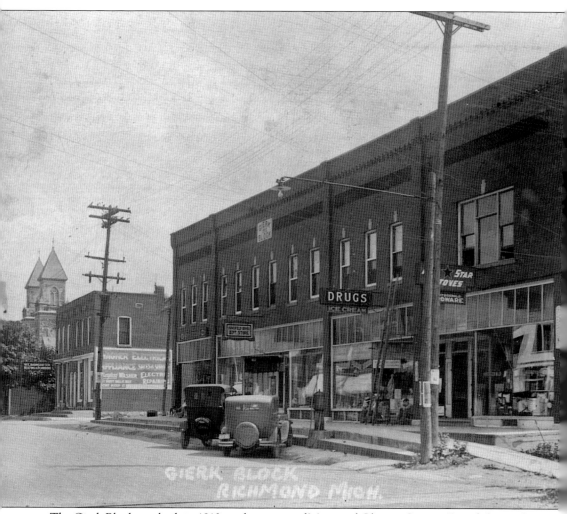

The Gierk Block was built in 1910 on the corner of Main and Gleason Streets. From left to right are Gierk Shoe store, Binsfeld Brothers Department Store, Stier's Drug store, and Fitzgerald Hardware store selling Red Star Stoves. Gierk sold shoes on the first floor and pianos on the second floor. The department store location was also the Polewach Department Store and Neddermeyer's. The Polewach store was opened briefly from 1929 to 1930, run by Ted and Stella Swartz. They reopened in 1934 and operated it until 1965. Stier's Drug store was bought from John Lutes in February 1920. The drugstore sign also advertises ice cream. The hardware store was bought by Dr. J.A. Engels from M.E. Fitzgerald in 1939. Before Fitzgerald, Charles Stern and Frank Burr owned the hardware business.

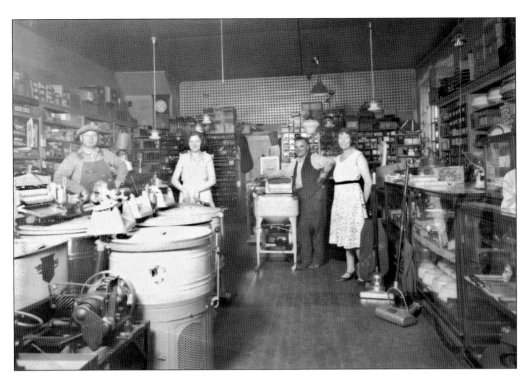

The photograph above shows the Wagner Electric interior with, from left to right, Harry Foss and Vonda, Fred, and Gertrude Wagner. Wagner Electric was located on the southwest corner of Main and Gleason Streets, in the right half of the building with the sign painted on the wall. Franklin Wagner started the business in 1923 after giving up running a theater in town. His son Franklin "Bud" Wagner took over on his father's death in 1940, selling and repairing appliances. The other half of the building was used by Baumgarten Plumbing and Heating.

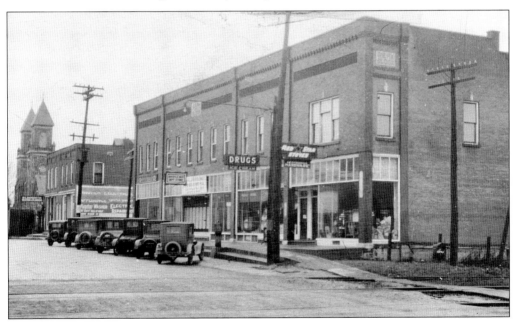

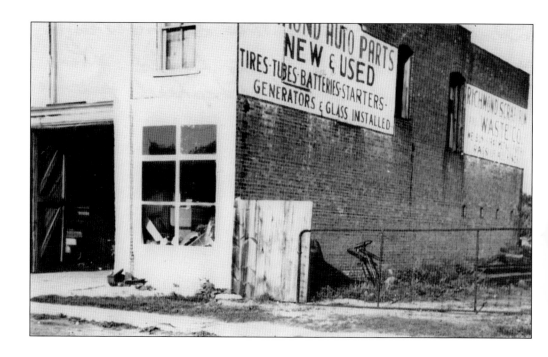

The photograph above shows the 1945 Richmond Auto Parts and Richmond Scrap and Waste business on Grand Trunk Avenue. In March 1946, Frank and James Shepherd purchased the building and started Shepherds' Auto Parts business. They sold parts, serviced vehicles, did body work, and bought and sold used cars. In 1948, they added an addition to the back of the shop, as shown in the photograph below. The business grew and is now the Shepherd Lincoln dealership.

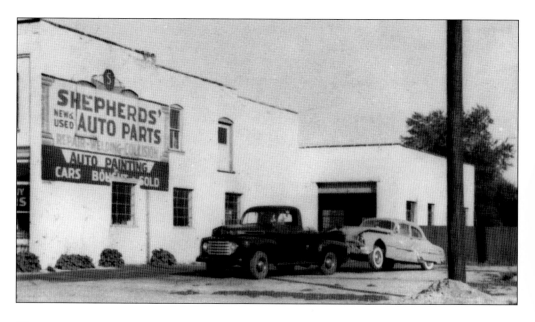

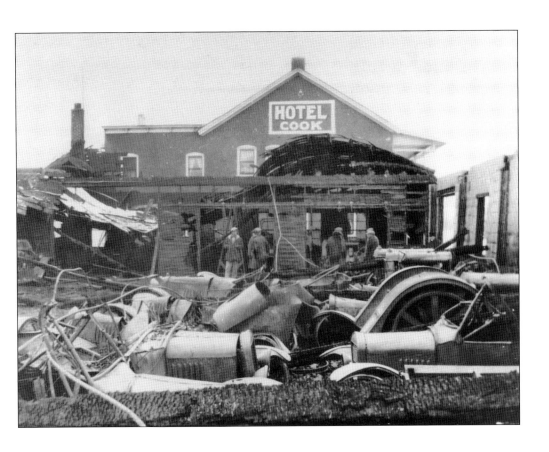

Donovan Brothers Ford Agency was destroyed by fire in 1925. J.C. Ernst rebuilt on this site located at Main and Beech Streets and opened in April 1926 as the Ford Car and Truck Agency. They also sold gasoline as seen in the 1930s photograph below. In the background is the Cook Hotel, formerly the Glenwood.

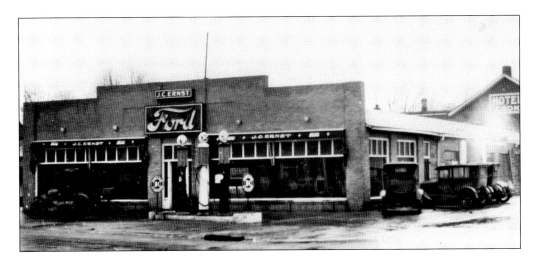

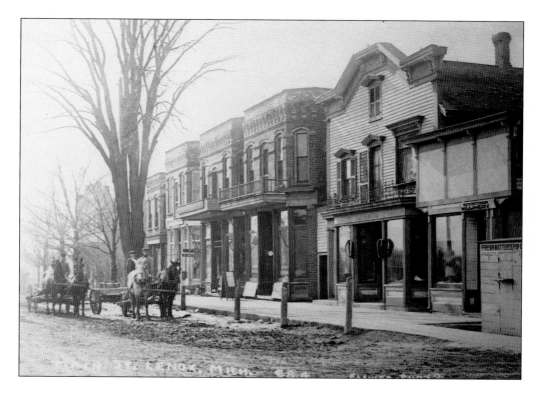

The west side of Main Street between Friday Street and Grand Trunk Railroad was commonly known as the Lovejoy Block. Ira Lovejoy owned and operated a general store in this block for years, and his store is the second building from the right, above and below. The first store was at different times Ruth Patterson Millinery, J. Heath Store, A.J. Kludt Jewelry Store, and Herman Ruemenap's Shoe Store. The third building was E.R. Brietenbacher, MD, and Dr. Fenton's office. This building eventually housed Webb's Café. The fourth building housed Hats & Footwear, followed by Merriman & Bishop Clothing. The sixth building was the original home of Macomb County Savings Bank and eventually became the home of Fiedler's Tailor Shop. The final building on the block was the Central Transfer and Storage building, constructed about 1890 by Gilbert R. Lovejoy.

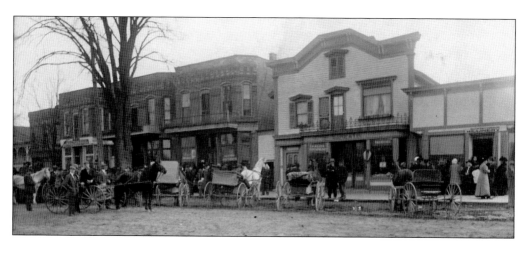

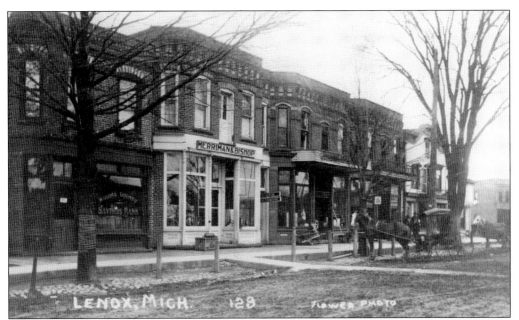

The Macomb County Bank, at left in the photograph above, was organized in 1898. The business office was in a storefront on the west side of Main Street, north of the railroad tracks. The new building was completed in 1923, constructed almost in the same location. During the 1933 New Deal Bank Holiday, the bank was liquidated. It reorganized and reopened as a member of the FDIC on April 4, 1935, with Harold Parker as president. The bank's business merged with First State Financial in 1989. In the same year, the bank building was acquired by the City of Richmond and is currently being used as city hall.

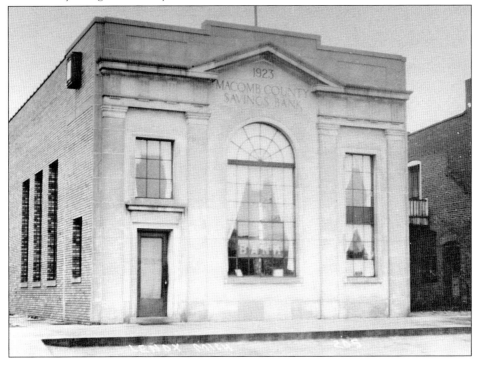

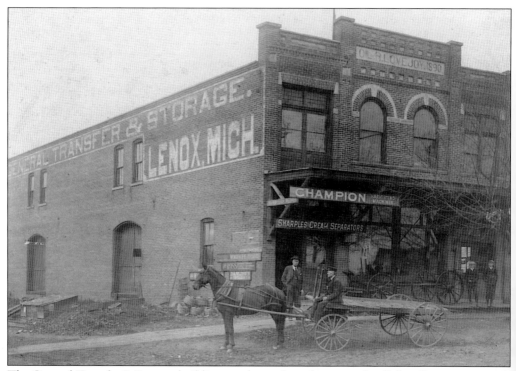

The Central Transfer & Storage building was located on the west side of Main Street, just north of the Grand Truck Railroad crossing. The structure was constructed by G.R. Lovejoy in 1890 as a farm implement store and storage building. Later, it was used as a theater and post office. After the theater moved out, the Damor Manufacturing Company had a business in part of the building. They sold out to Richmond Manufacturing (Toy Factory), owned by John Ross and Howard Tanner of Detroit, who began their business in Richmond during the early to mid-1940s.

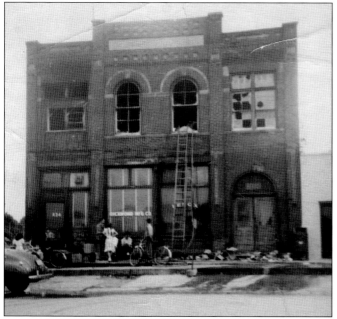

The company that made metal toy trucks burned on September 17, 1948, destroying all toys ready for shipping to stores for Christmas sales. All that was left of the building, pictured at left, were the brick walls. At the time of the fire, the building was owned by J.C. Ernst. He rebuilt, and Karmon's Hardware store opened there in 1949. Ted Karmon had been in the hardware business since 1932.

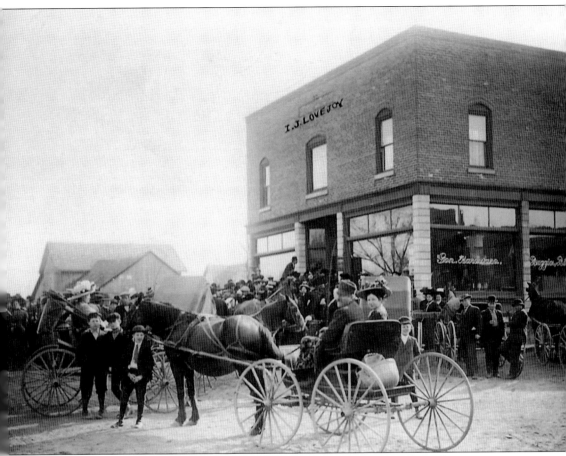

The store above was built by Ira Lovejoy on the corner of Friday and Main Streets. Lovejoy was a well-known and prominent citizen of Richmond, operating a general store on South Main Street for many years. He also began selling general merchandise from this store as well as hay and wool. People are gathered outside for a prize drawing, which was a popular method used by businessmen to attract customers to their stores.

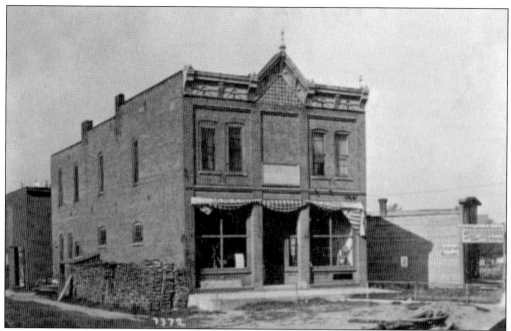

The Friday's Furniture Store building above was located on the northwest corner of Friday and Main Streets. Friday's store became Ben Duengel's Men's Clothing Store in 1945. He had been in the clothing business for 26 years prior to this. His wife, Maxine, assisted him in this store. Ben Duengel was village president from 1947 to 1949.

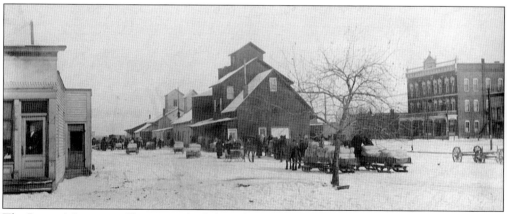

The Beatty Monument Shop is on the left in this photograph. David Calvin Beatty (1820–1898) and his family relocated from Canada to Kimball Township around 1863 before moving to Beebe's Corners. He started the Beatty Marble and Granite Shop in 1871 on Division Street, west of Main Street. Later, they moved the business to Ridgeway/Lenox, locating the business near the Farmers' Elevator. The business operated for quite a number of years.

Five

MUTTONVILLE/EAST LENOX

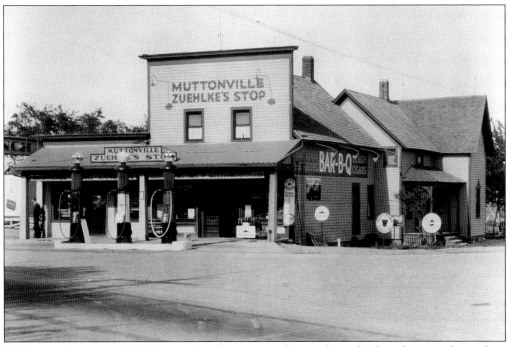

William and Augusta Zuehlke purchased a grocery, dry goods, and saloon business located on the northeast corner of Gratiot Avenue and Hart Road (now 31 Mile Road), from a Mr. Rath in 1893. This business in Muttonville, or East Lenox as it was sometimes known, was called Zuehlke's Stop. Zuehlke operated the business until his death in 1906. His son William Frederick C. Zuehlke then managed the business until his death in 1911. William Frederick's son Fred William helped run the business and acquired ownership in 1929.

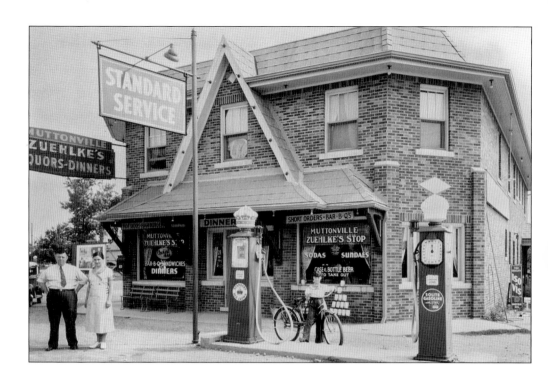

In 1930, the original Zuehlke's Stop was torn down and the new building with its fine, modern, and beautiful brick edifice took its place. Fred and Hazel Zuehlke, seen in both photographs, operated the business until 1941, when it was sold to Frederick Eberhardt. Eberhardt emigrated to the United States from Germany in 1913 and had retired from his meat and cattle buying business. Eberhardt's was operated by Frederick and his son Frederick W. from 1941 to 1993, when the business was sold and Fred W. retired.

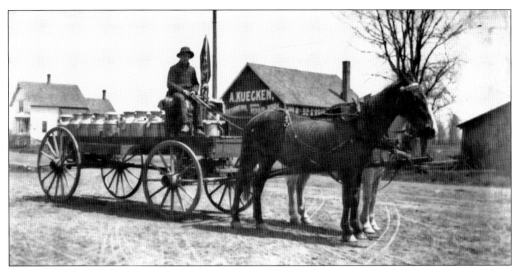

The Fred Schwark home in the background would be on the east side of Gratiot Avenue close to the Main Street intersection. Fred's son Bill and his wife, Ella, lived in the house until their deaths in an auto accident, which occurred in front of their home on the day after their 50th anniversary. The property became the site of a Kroger store. Fred is seen here driving a wagonload of cream from the East Lenox skimming station to New Haven.

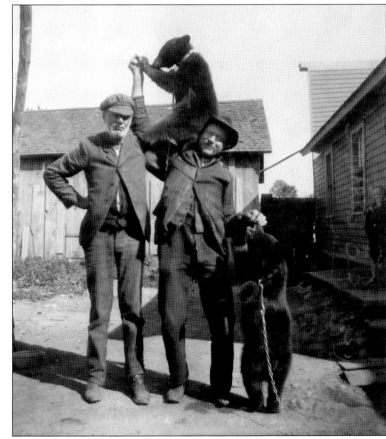

Fred Schwark is shown holding bears Ted and Mike behind his first store on the west side of Gratiot Avenue, just north of the Lutheran church. The man on the left is unidentified. Schwark had a number of wild animals that he liked to show off.

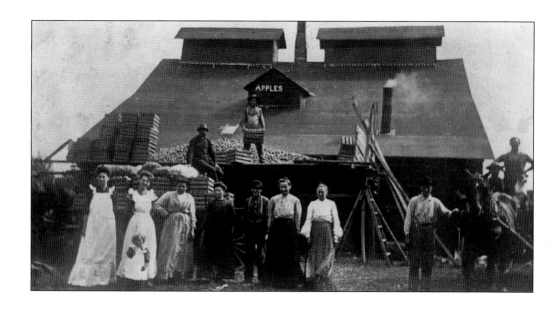

Fred Schwark's apple-drying operation was located east of Gratiot Avenue at Main Street. The little girl is six-year-old Alma Schwark Maedel (b. 1890). Her mother, Wilhelmina Schwark, is the second woman from the right. Below is the Fred Schwark & Son Grocery and Saloon, located across the street, next to the Lutheran church. In 1904, Fred Schwark traded his property in Bay County to W. Baars for this store and saloon and moved his family to the apartment above it. He sold this business in 1909 and bought a blacksmith shop across the street, converting it into a grocery store and truck stop restaurant. Below are, from left to right on the wagons, Elwin and Fred Schwark.

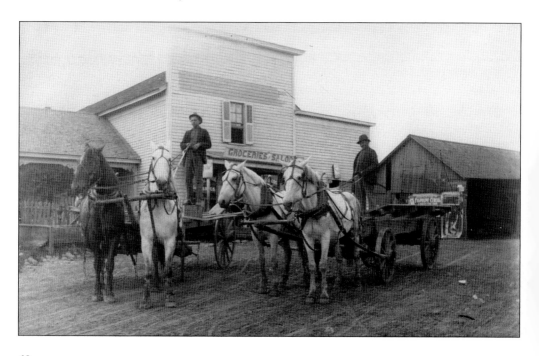

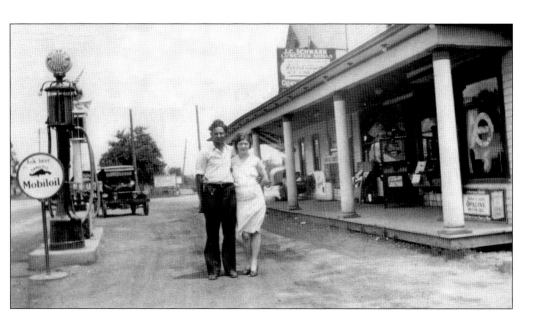

Schwark's Stop is shown above with the restaurant on the right and Beamus Bentley and Loretta Schwark in front. The photograph below shows the interior. It was one of Muttonville's oldest businesses, having been in continuous operation by the Schwark family from 1909 to 1950. It operated as restaurant and bus stop. In the photograph below are, from left to right, Jake Schweiger, Charles Stoecker, John Carl Schwark (1889–1950), and wife Lila Foss Schwark (1891–1980). The business was leased to Frank and Hannah Tucker in 1950.

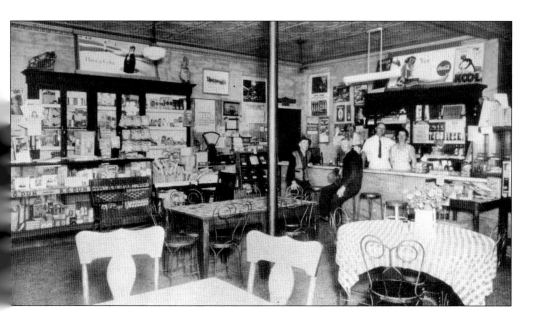

Fred Fahs Garage was built in 1924, just south of Hart Road (now 31 Mile Road) on Gratiot Avenue. Fred lived in this building and offered 24-hour wrecker service, aside from selling Sunoco gasoline. On July 1, 1938, this became the site of the Macomb-St. Clair County Consumers Cooperative. The co-op started off by selling and delivering petroleum products. They purchased a 546-gallon tank and mounted it on William Dueweke's Ford truck shown below. William made the truck deliveries and was appointed manager in March 1938. The first delivery to a farm was made April 30, 1938. It was an exciting event for the members when the truck known as "Old Faithful" first made an appearance at their homes.

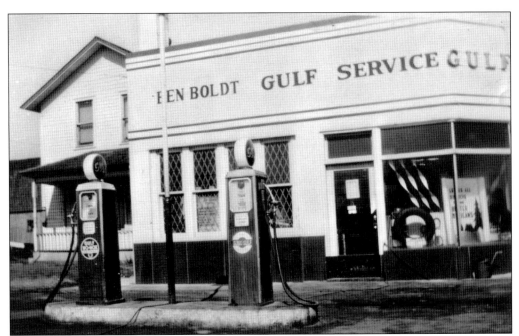

Ben Boldt's service station was located on northwest corner of Gratiot Avenue and Main Street in what was Muttonville. Ben Bolt (1905–1967) taught school from 1928 to 1941 and 1959 to 1961. He was also a football coach for Richmond Community Schools in the 1920s and 1930s. As a football coach, he led the high school to a 1938 Tri-County League championship. He also served as a justice of the peace in Lenox for 12 years. Ben married Mary Lou Bryant, a Richmond schoolteacher in 1937. He was a member of the Richmond Lodge, No. 187, F&A.M.

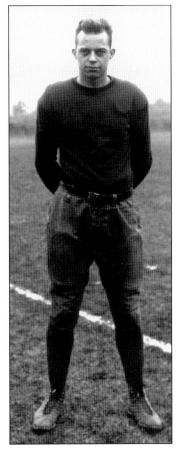

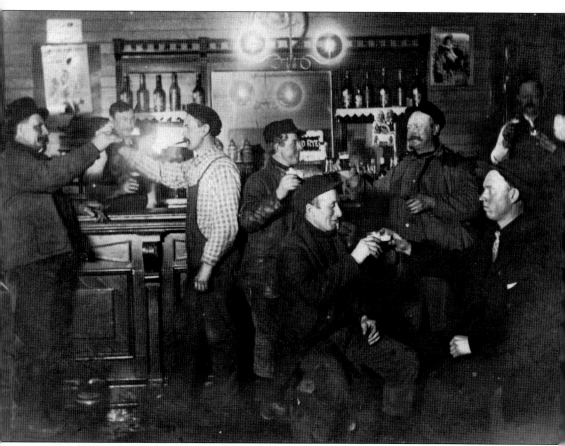

This photograph was taken at Zuehlke's Saloon in Muttonville on January 29, 1907, after the men came in from sawing ice at the Pound's pond for summer sale. Most of the ice these men sawed was probably used by the Weter, Fanning & Company, located at the north end of town. This must have been a popular tavern, as the pond was located two miles north of it. One version of how Muttonville got its name was that they slew mutton there in the 1880s. The name East Lenox never caught on as well as Muttonville did. From left to right are Charley Froh, bartender Charley Stoecker, Fred "Fritz" Wendt, Henry Marserick, John Marserick, Charles Foss, Alvin Schwartz, and saloon owner William (Bill) Zuehlke.

Six

SCHOOLS

The graduating class of 1896 attended classes held in Richmond High School, located on School (now Grove) and Park Streets. In this photograph are, from left to right, (first row) Frank Gillett, Edna Bernard, and Ella Grinnell; (second row) Lettie Claggett, Nora More, Supt. Jesse Tice, Lily Learn, and John McDougall; (third row) William Sippell, Will Fitzgerald, Addie Henry, and Ralph Keeler.

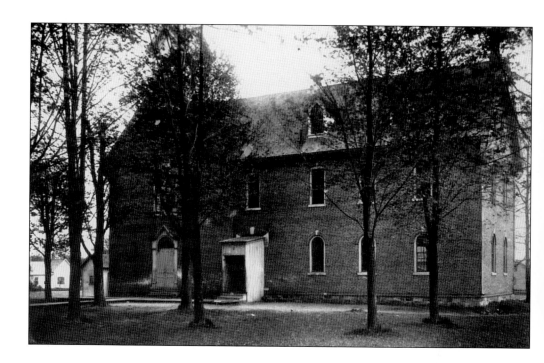

The first Richmond High School was built in 1874 on land donated by Seth Lathrop. It was bounded by Park Street on the south, Churchill Street on the north, and Grove Street on the west. Two outdoor privies were located on the right. The second floor was used by ninth through 12th grade classes, and the first floor was used for chart class (kindergarten) through eighth grade. Some students attended classes in the fire hall when the number of students exceeded the capacity of the school building. Some of the first principals were H.F. Smith, G.H. Burgess, E.L. Briggs, A.E. Millett, R.J. Crawford, J.M. Tice, L.A. Suydan, and W.L. Lee. Local residents gather together for the Farmers Festival on the grounds of Richmond High School on August 31, 1910.

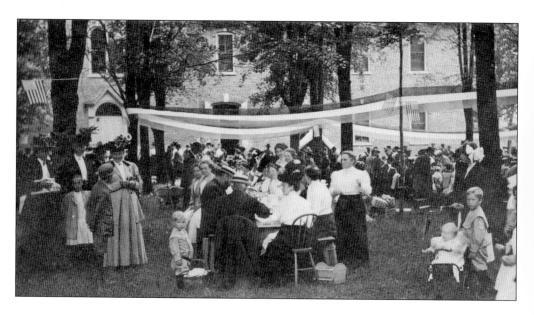

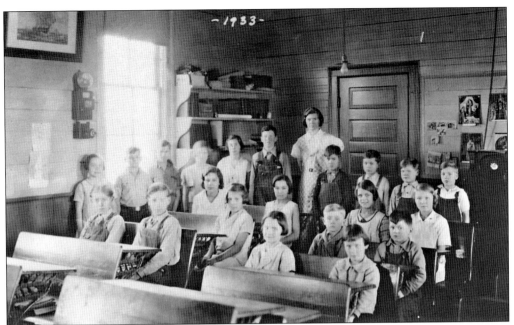

The Ruth Montgomery-Brown photograph above shows the inside of the School Section Road schoolhouse in 1933. From left to right are (first row) Gilbert Wahl, Richard Simons, Grace Plagens, and Inez Plagens; (second row) Lucille Simons, Eldon Wahl, and Robert Seifert; (third row) Caroline Simons, Ruth Montgomery, Vonda Kulman, and Beatrice Wahl; (fourth row) NaDean Plagens, Charles More, Herman Fuerstenau, Aleta Plagens, Christabell Palmer, Elroy Plagens, teacher Hilda Thiele, Robert Kulman, Martin Montgomery, Elmer Kulman, and Robert Simons. The photograph below also shows the interior of the School Section Road schoolhouse. The students are unidentified.

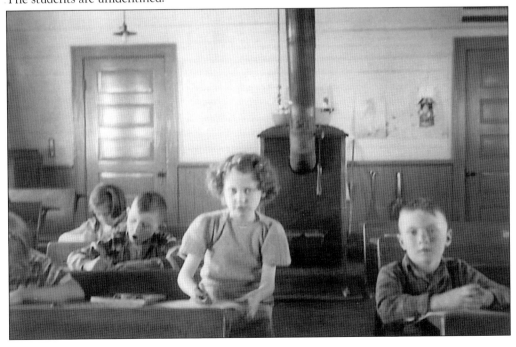

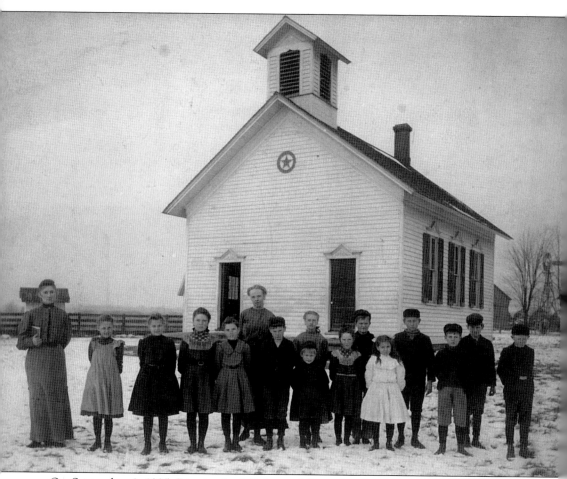

On September 1, 1885, District 3 of Richmond Township had their annual meeting of "legal voters" at the schoolhouse. Motions were made and passed to build a new schoolhouse on the site of the existing one. It was voted to raise $300 by bond to pay for it. A motion was made to have students attend four months of summer school and three months of winter school. A building committee was formed to draw up specifications for the new school. Additional meetings were held, and finally at the December 4, 1885, meeting, it was agreed to let the contract for the construction of the building to O.P. Chafrin for $449. On January 19, 1886, the school board met at the Richmond Bank where $300 in bonds was taken by William H. Acker. On June 25, 1886, the building committee accepted the new schoolhouse "without fault." This schoolhouse was located on School Section Road and was in use until 1953. On February 16, 1994, it was moved to Bailey Park in Richmond to be part of the Richmond Historical Society's historic village.

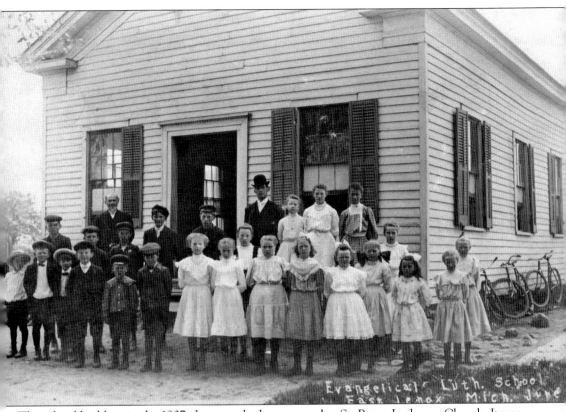

Evangelical Luth. School
East Lenox Mich. June

The school building in the 1907 photograph above started as St. Peters Lutheran Church. It was built by the congregation in 1863 on the northwest corner of Gratiot Avenue and Hart (now 31 Mile) Road. By 1875, a larger church was built next to this one, which was converted to a one-room schoolhouse. Pastor Lohrman served as the first teacher. In 1888, F. Prange was hired to teach. When he resigned in 1893, William Hahn, pastor J.L. Hahn's son, took his place until 1897. In 1950, these two structures were replaced by a new church and a modern two-room school. The school has continued to expand with additions being built to accommodate an expanding student body. Located behind the school and church was a stable used for the horses that brought the congregation to church.

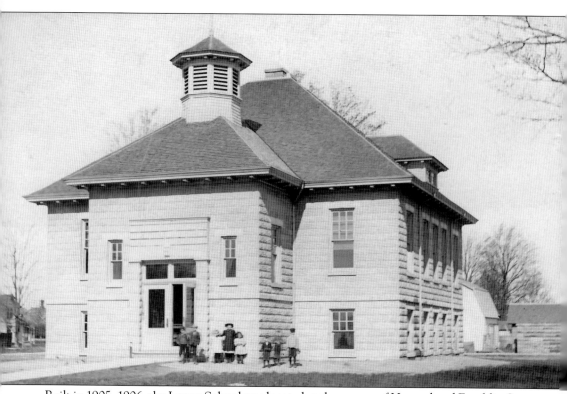

Built in 1905–1906, the Lenox School was located at the corner of Howard and Franklin Streets. It took the place of a two-room schoolhouse built sometime after 1859. That school was located on Howard Street with the back of the lot near the end of Lane Street. That building was condemned as being in an unsanitary location next to a hog pen. The Lenox School operated as a public school at first and later as St. Augustine Catholic School. As a Catholic school, there were up to 46 students in each of the four class rooms. It was torn down, and the site became part of the playground.

St. Augustine School, located on the west side of Main Street between Howard and Gleason Streets, opened for classes in 1930. This had been the site of the wood-frame Catholic church moved there in 1910 to make way for the new church building. Previously, the highest grade level was ninth grade, but by 1934 the first 12th grade class graduated. A high school was constructed behind this building and was in use from 1961 to 1968. It is currently being used as a grade school. The building above is now being used as the parish hall.

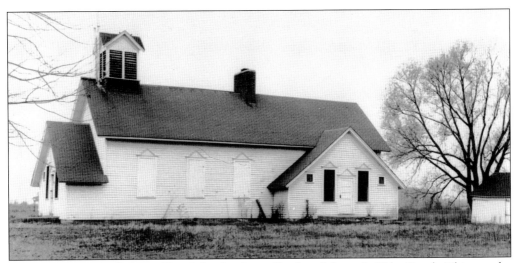

This 1958 photograph shows West School at Lowe Plank and Armada Ridge Roads. This was the third school built on this site; the first was in 1840. The second was a two-story school built in 1855–1856. The younger children were taught on the first floor of the building, and older students on the second. The third structure was built in 1870. In 1934, the teacher for this school was Ruth Fries. Today, it is the Community of Christ Church.

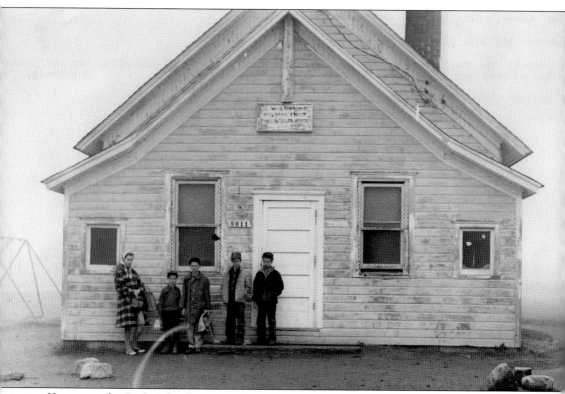

Known as the Pink School House, this Columbus Township, District 7, school was located at Palms Road and Gratiot Avenue. In 1934, the teacher for this school was Pearl Hensch. This and other schoolhouses like it survive today and have been converted to other uses, such as residences, church buildings, and businesses. A one-room schoolhouse like this was still in use in the Richmond School District as late as 1960.

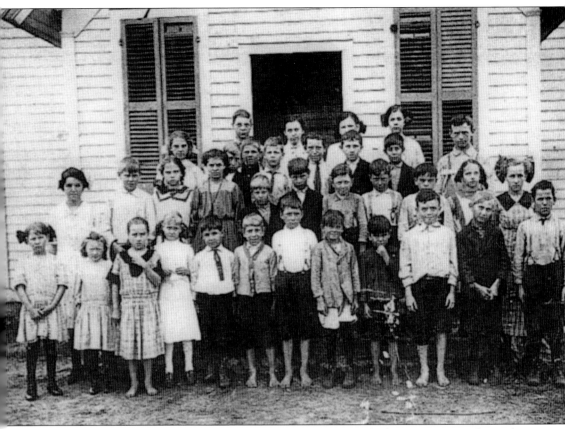

The Columbus School was located on the east side of Kronner Road, about a quarter mile north of Pound Road, around 1910. It is interesting to note the number of students who are not wearing shoes. These students walked up to two miles to attend this school. From left to right are (first row) Evelyn Conklin, Margaret McKiernan, Lucy Allington, Marie Marden, Edgar Weeks, Elgin Quick, Lloyd Quick, Frank Zimba, Wilfred Kronner, Francis Kronner, Erving Bartel, and Clarence Rabins; (second row) Marie Kronner, Osman Evans, Frances Ottenbacher, unidentified, Ivan Hamilton, Melvin Conklin, Tom McKiernan, Roy McKiernan, Charles Kronner, Adelaid Ottenbacher, and Sadie Allington; (third row) Mary Ottenbacher, Seifert Allington, Paul Morden, Manson Lowell, Alfred Lowell, Alfred Rabine, Carl Bartell, Marvin Hamlin, and Earl Prior; (fourth row) Smith Lowell, teacher Jenny Fenton, Gertrude Evans, and Marie Lowell. (Courtesy of Mary Hnatiuk.)

Will L. Lee Elementary School, for kindergarten through sixth grade, was built in 1954. It was named after a longtime educator and superintendent of the Richmond Community Schools. It was the first "modern" school built in the district. The classrooms for kindergarten through third grade each had a restroom in them, and each room had its own exterior door. Shortly after it was built, students were asked to pick up stones from the playground behind the building and put them in a hole dug for that purpose. Additions have been made to this building over the years.

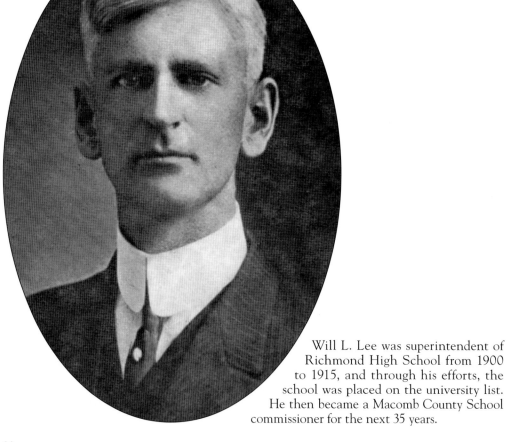

Will L. Lee was superintendent of Richmond High School from 1900 to 1915, and through his efforts, the school was placed on the university list. He then became a Macomb County School commissioner for the next 35 years.

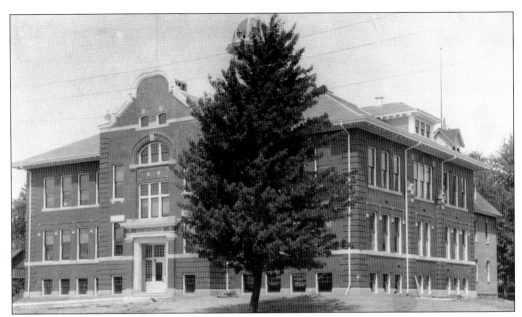

A new Richmond High School was completed in 1913. The first one, located behind it, was torn down later. This photograph shows the south entrance on Park Street. There was a gymnasium in the basement, which was later converted into classrooms. This school educated seventh through 12th grade students until December 1959, when the present high school opened. The students moved all of the furniture out of this school and into the new one in one morning before Christmas vacation using farm trucks and tractors with hay wagons.

Lola B. Weeks came from Clinton, Michigan, in 1923 to become the high school principal. Her other duties included teaching Latin, coaching girls basketball and cheerleading, advisor for the yearbook and senior class, and chaperoning the Friday night dance that was held every week on the second floor.

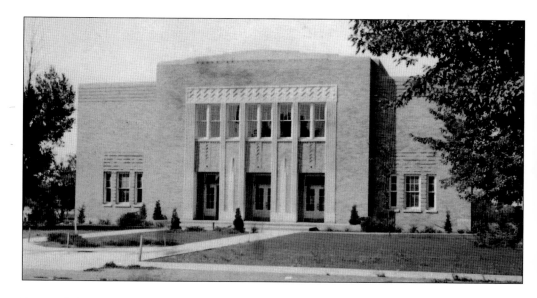

Roosevelt (Civic) Auditorium, on the west side of Main Street just south of Division Road, was built during the Great Depression. The residents voted 147 to 25 to raise $8,500 with a one mill tax for a period of five years in order to receive $38,000 from the government to build it as a Civilian Work Administration project. It ended up being a Works Projects Administration project, and the cost went to $50,000. This project provided work for 50 local men. The cornerstone was laid on November 30, 1934, and the 1935 high school commencement served as the dedication ceremony. There was a library on the second floor, a basketball court, and a stage for musical and theatrical productions on the first floor. Shop classes were held in the basement. It also served as a polling station during elections. Below, the first Richmond school bus is parked in front of the high school on Park Street waiting for students to board at the end of the school day.

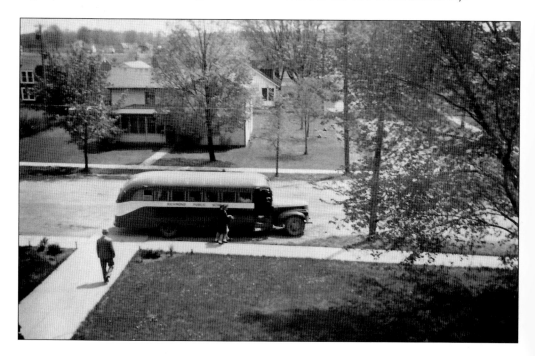

Seven

CHURCHES

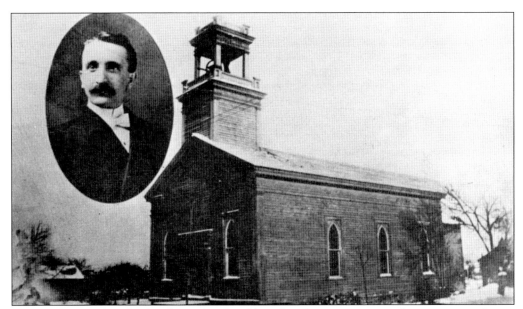

The Methodist Church of Richmond is the oldest church organization in the community. It can trace its history back to 1837 when Jeremiah Norton conducted the first religious services in the log home of Daniel Hall that was located about where the cemetery soldier's monument is. A charter for the First Methodist Episcopal Church was granted in 1840. The wood-frame church seen here was built on the northwest corner of Armada Ridge and Lowe Plank Roads about 1857. This church was moved on rollers in 1867 to Prospect Street (Circle Lane), renovated, including new pews, and used for the next 40 years. The Reverend Waldron Geach (insert) was pastor in this church. He worked with the men building the new church and helped raise money to pay for it.

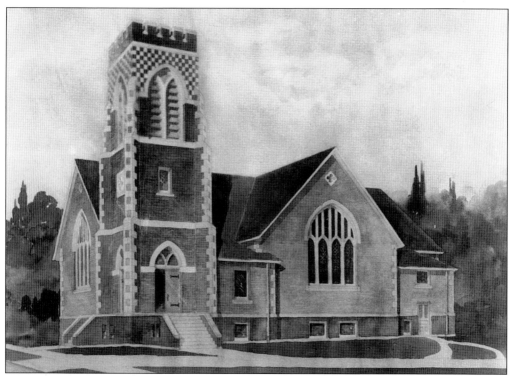

The architect's rendering of the new church that was built in 1907 is seen above. The photograph below shows the Methodist Church around 1960. Since then the houses located to the left of the church have been torn down for a parking lot, and a new entrance with an elevator has been added to the front left corner.

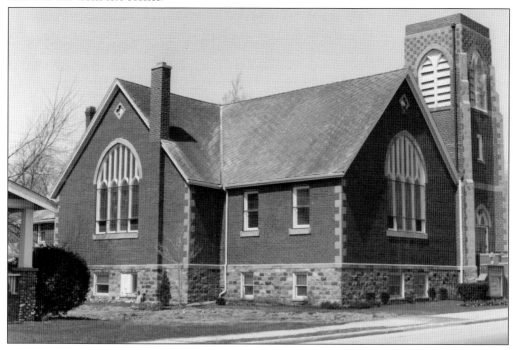

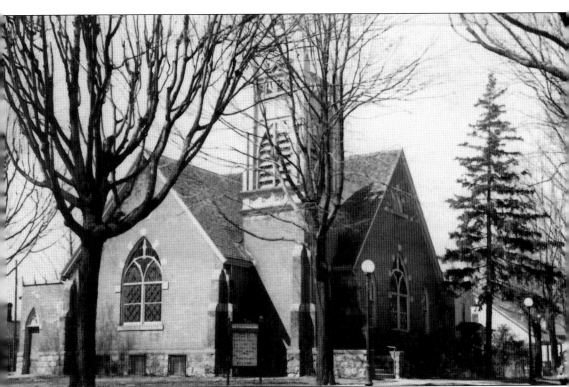

This c. 1940 photograph shows the First Congregational Church located on the northwest corner of Churchill and Parker Streets. On September 26, 1871, a group of people met in Dr. D.G. Gleason's office to organize a congregational society. Forty-five people became charter members. The trustees included E.N. Beebe and Seth Lathrop. Charles S. Knight was named treasurer and Sanford S. Stone was named clerk. A committee was appointed to raise money to build a 22-by-24-foot church. Seth Lathrop donated the property for the building site. The church was completed March 13, 1872. The Reverend S.O. Bryant was the first pastor. In February 1884, it was decided to build a new brick church for about $3,500. The cornerstone was laid June 6, 1887, and the church was dedicated that December. In December 1970, the First Congregational Church and St. Paul's United Church of Christ voted to merge and became the First United Church of Christ. In 1973, this building was purchased by and is now being used as the Richmond Center for the Performing Arts.

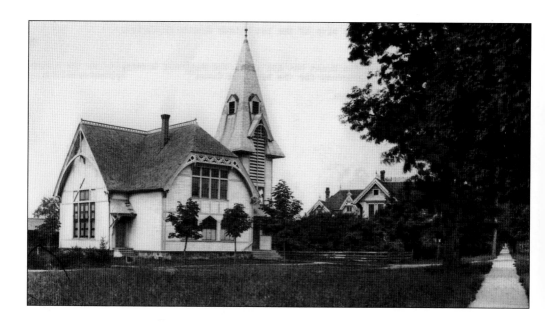

The congregation of the Deutsche Evangelische Sankt Jakobi Gemeinde built a church on the corner of South Forest Avenue and Main Street in 1889. They remodeled the church (above) in 1913. The photograph below may have been taken at a rededication of the remodeled church. In 1928, the name was changed to First Evangelical and Reformed Church. The church below burned on February 1, 1931, when a fire started during Sunday school classes. A brick church was built to replace it, and until it was finished, services were held in the village hall. Today, this is the site of the United Church of Christ.

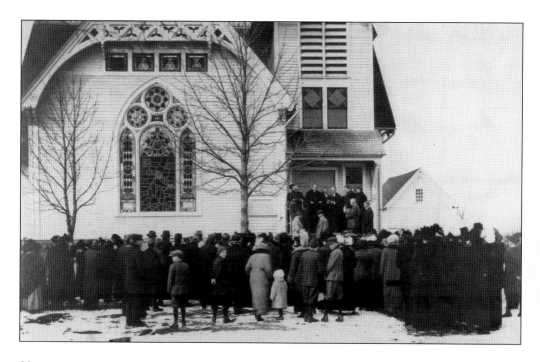

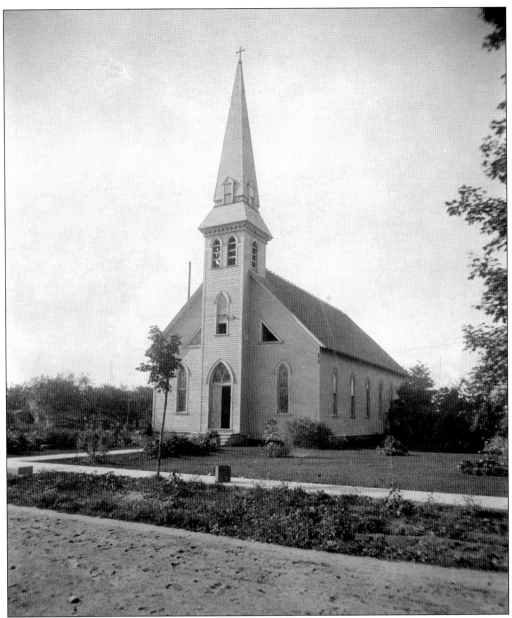

The foundation for this first St Augustine Catholic Church was laid in 1887 on the northwest corner of Howard and Main Streets. Prior to this, Catholics attended church services in Columbus, Anchorville, or New Baltimore. Services were also held locally at the residence of Mary McCarthy.

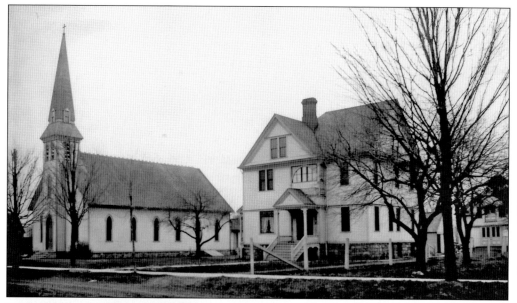

The first St. Augustine Catholic Church was located on the northwest corner of Main and Howard Streets in this c. 1900 photograph. The house on the right served as the Catholic rectory. The wood-frame church was moved in 1910 to the right of the rectory to make way for the present church building. The parsonage was replaced with a new structure in 1926.

Fr. Edward Schrauder (1868–1934) was the pastor of the St. Augustine parish from 1905 to 1934. During his tenure, the wood-frame church and rectory were replaced, and a new school was built.

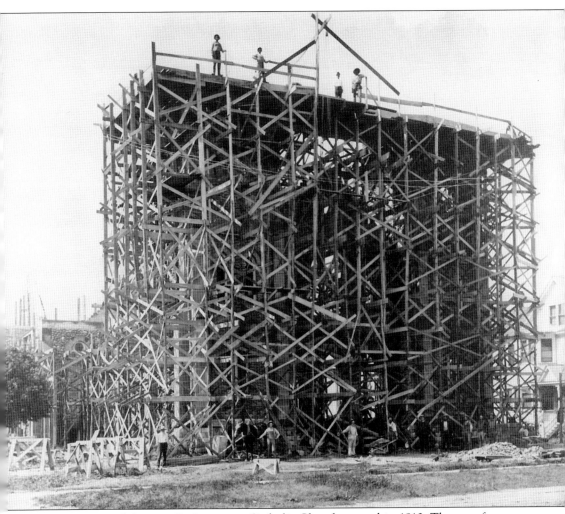

The construction of the new St Augustine Catholic Church started in 1910. The area farmers hauled over 2,000 wagonloads of field stones cleared from their fields to the construction site at Main and Howard Streets for use in building the church. William Schurke, considered the finest stone mason in the area, lived in a small house facing the church. He was retired and had several physical disabilities. Father Schrauder seemed to be the only one that thought William Schurke could do it and got him to agree to take the job. William said he would do the work as long as only hand-mixed mortar was used and that he would have enough help to keep him busy. Not long after the church was completed he passed away.

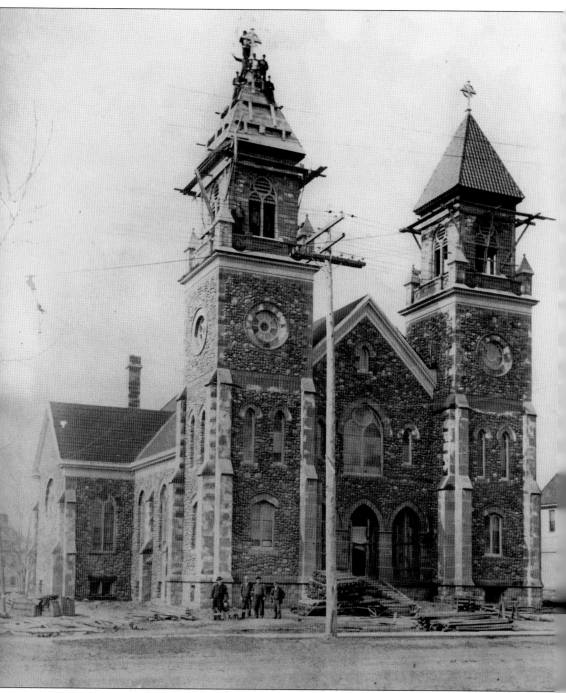

The St. Augustine Catholic Church as it nears completion shows the use of field stones from the local farmers' fields. It was built on the same site as the first wood church on the northwest corner of Howard and Main Streets. The church was dedicated December 11, 1913. This may be the tallest building in the community, rising 86 feet from the ground to the bases of the crosses.

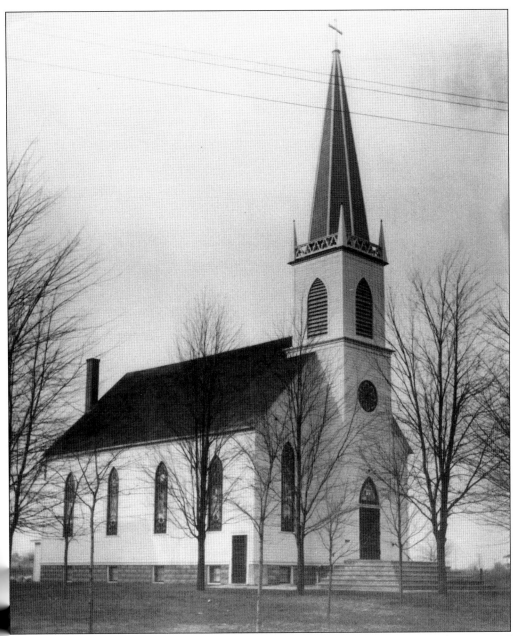

In 1863, the St. Peters Lutheran Church congregation built a small church on the corner of Gratiot Avenue and Hart (31 Mile) Road in what was Muttonville. In 1875, the congregation constructed this church to replace the first building. Starting in 1873, the pastor taught school in the first church building until 1888, when a regular teacher took over those duties. The first church building was used as a school until 1950.

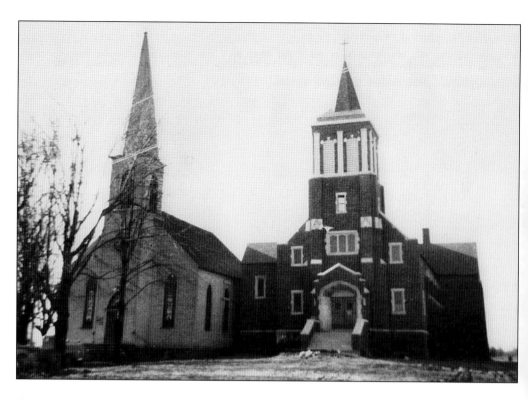

A new St. Peters Lutheran Church, on the right above, was completed in 1950 along with a more modern, two-room schoolhouse. Additions were added to this school in 1975 and again in 2002. Both of the original church buildings were torn down, and the materials from them were used for other construction projects around the community. The front of the first church building can just be seen on the left below when it was being used as a schoolhouse.

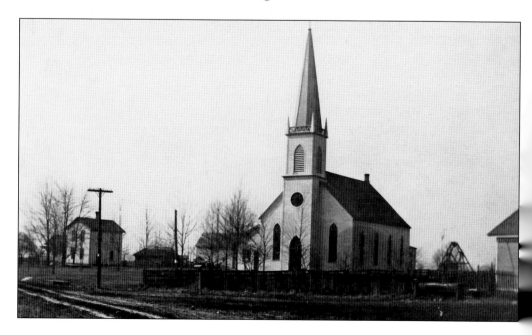

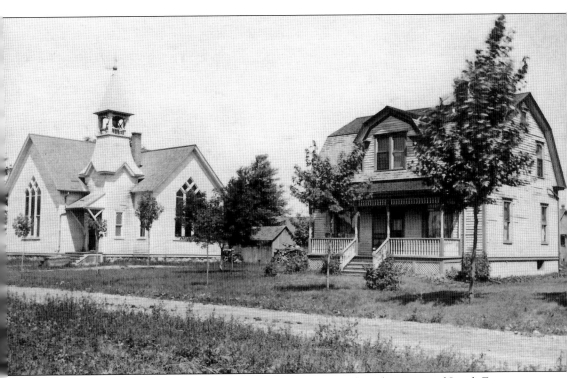

The Immanuel Church of the Evangelical Association was located on the corner of South Forest Avenue and Friday Street (foreground). The church originally was built on Church Road (30 Mile Road) and Gratiot Avenue in the early 1870s by the Germans who had settled that area. The organization was formed December 30, 1874. On August 8, 1901, the church board agreed to buy a lot from Ira Lovejoy and move it to Ridgeway (Lenox). Once the structure was moved, an addition was built. In 1904, it was decided to have German and English church services on alternate Sundays. By 1910, after the congregation had shrunk to nine families, the church as an organization was dissolved. Since then, this church has served the congregations of Trinity Lutheran and Zion Methodist. It currently is the Community Baptist Church.

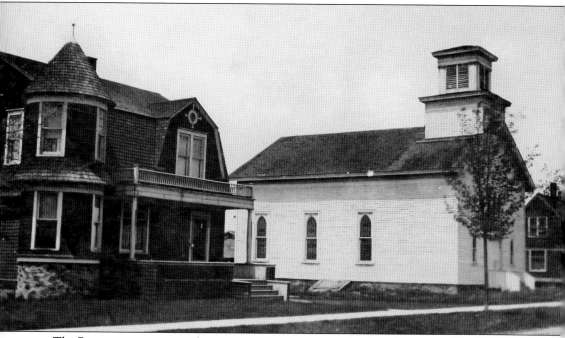

The Baptists met in private homes prior to 1869. They held classes in a rented building that later became the Lenox Post Office building. Their building committee met on March 1, 1870, to plan the building of the church seen here. A lot was donated by Daniel Gillet, and the church was completed on February 25, 1871. At this time, the Reverend Silas Finn served as pastor. In 1880, the congregation erected a parsonage on a lot bought from Thomas Conway. This Baptist church was located on the southwest corner of Division Road and Main Street in front of where the Roosevelt (Civic) Auditorium is located today. The house on the left was the former residence of Blanche Pulver. It was purchased by the Richmond school board, who in turn sold it at auction to Earl Schieble. He moved it to the northwest corner of Beech and Priestap Streets in March 1952.

Eight

FARMS AND HOMES

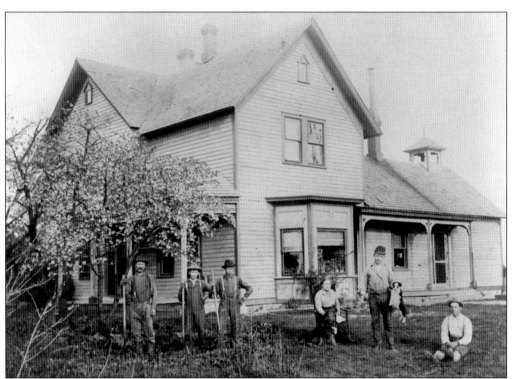

This c. 1900 photograph shows the Ira Weeks farm on Pound Road. The woman in the chair is Lucy Vogt Weeks, wife of Ira Weeks. Two of their seven children are seen here. Ray Weeks (1882–1959) is holding the dog, and Fred Weeks is sitting on the ground. This farm was first settled by David and Mary Weeks, who were among the earliest settlers in that section. The farm was located partly in the townships of Richmond and Columbus. This house, which burned in the late 1920s, was located on the south side of the road, east of the Grand Trunk Railroad tracks. The cupola over the kitchen area housed a bell to summon the men in from the fields for meals.

This horse is being led by Gertrude Ann Weeks Foster on the Ira Weeks Pound Road farm. This is the same farm house that is shown on the previous page. Gertrude was the sister of Fred, Ray, Melvin, Cora Weeks Heath, Florence Weeks Lindke, and Frances Weeks Franklin. The women on the porch are unidentified.

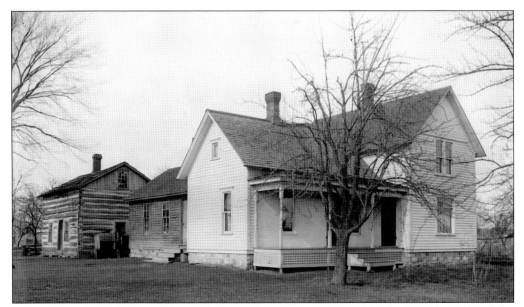

The E. Nichols residence was located on South Forest Avenue and had a log cabin behind the house. This is a fine example of how a settler started with a log house and worked up to a two-story, wood-frame house. This home is located at the very end of Forest Avenue where it meets 30 Mile Road in Lenox Township.

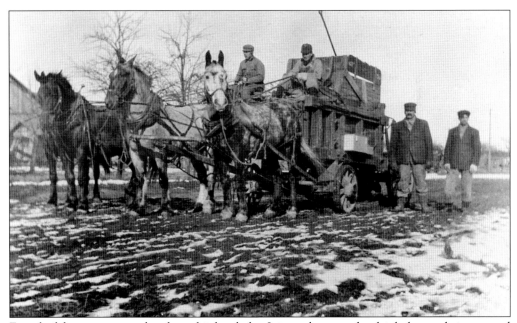

Four draft horses were used to draw this hay baler. It is not known why this baler was being moved in cold weather. This was a stationary baler that required hay be brought to it for baling.

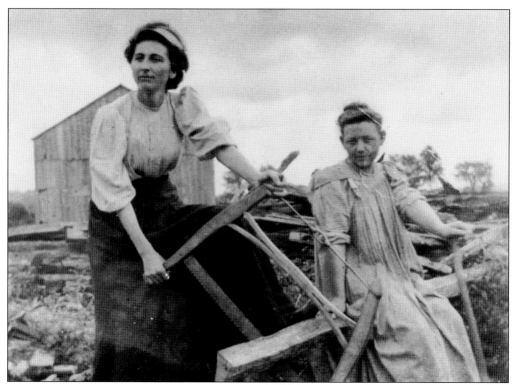

Lillie Hensch, wife of William Hensch, and Mary Hensch are "cutting" wood on the William Hensch farm located on 30 Mile Road near Gratiot Avenue. Cutting firewood would have been a major activity in order to cook food, heat water for washing clothes, and heat the home. It would be interesting to know why she has the saw in the wrong place for cutting wood.

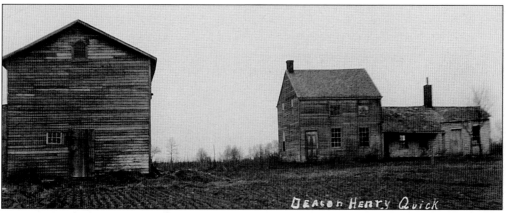

The Deacon Henry Quick family settled on this farm in 1836, residing there until 1886. The house appears to have been built in stages. Deacon Henry Quick (1809–1910) and his wife, Catherine, one of the founding members of the Columbus Congregational Church, relocated to the Richmond area from New York State. They settled in Columbus Township. It appears that no one is living here at the time this photograph was taken.

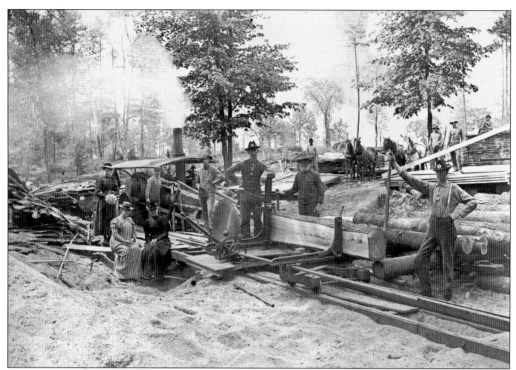

These photographs show a sawmill operation on the Ward farm using a steam-powered tractor to run the saw. Horses were important to this type of operation as well as general farm work. Lumbering timber did two things: it provided building materials for a growing community and it cleared land for farming. One of the uses for the lumber was to build plank roads.

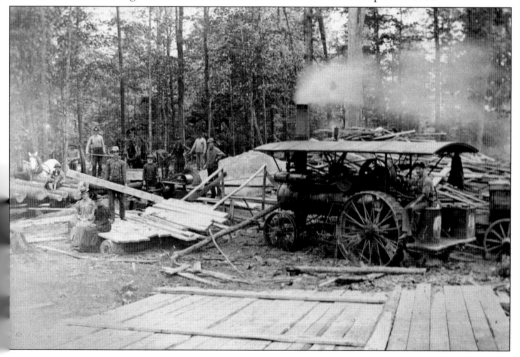

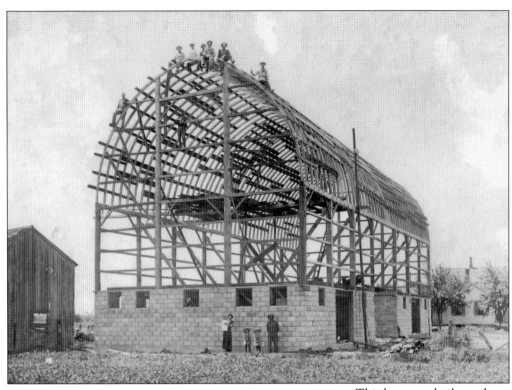

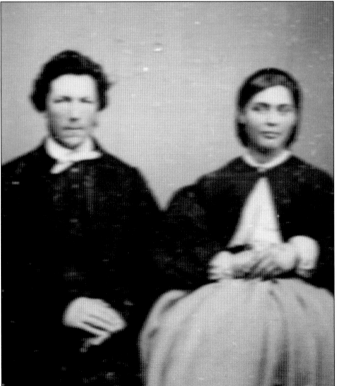

This barn was built on the Robert Ward farm in 1914 and was the first barn with a rounded roof in this area. It was 36 by 40 feet, 51 feet high, and could hold 100 tons of hay in the loft. Robert Ward (1838–1926) and his wife, Mary Jane Liscomb Ward (1839–1920), had come from Canada to settle on this farm 41 years earlier. Their first home here was a log cabin. In 1889, they built a 40-by-85-foot barn with a hip roof that was the largest one in the area at the time. Although Robert was driving to town in an automobile, he still worked the farm with steam engines and horses. His son Joseph and grandson Percy helped to work this 290-acre farm located at School Section and Wahl Roads where their second home still stands.

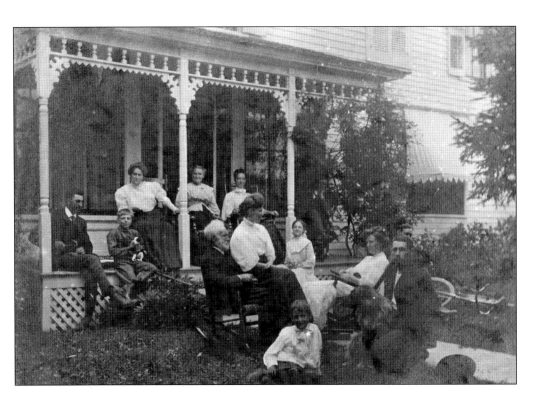

In the photograph above is a family gathering on the Ward farm. Pictured are, from left to right, (on lawn) unidentified and Joseph Ward; (in rocking chairs on lawn) Robert Ward, Lily Sayles, and unidentified; (on porch) William Rowley, Art Rowley, Mary (Ward) Rowley, Mary Jane (Liscomb) Ward, Caroline (Ward) Lovejoy, Marguerite (Ward) Fuerstenau, and Ira Lovejoy. The Ward farmhouse is still located on Lowe Plank Road. In the photograph below, Percy Ward is riding a cow as Marguerite Ward leads it by a rope that was tied around the horns.

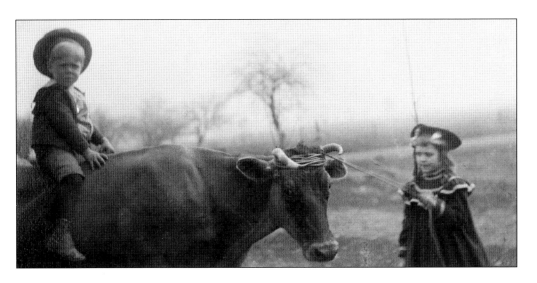

This photograph was taken around 1903 at the Fuerstenau farm that was purchased by Charles William Fuerstenau in 1902. It is located at the corner of Lowe Plank and Fuerstenau Roads in Richmond Township and is still owned by a descendant of Charles William Fuerstenau. The decorative ruby flash glass around the front door is somewhat unusual for a farmhouse. From left to right are (first row) Marjorie Simmons, Ralph Fuerstenau, and Gladys Mary Fuerstenau; (second row) Minnie Fuerstenau, Clarence Fuerstenau, Charles W. Fuerstenau, Minnie (Kemp) Fuerstenau, Carl Fuerstenau, Ora Amanda (Krise) Fuerstenau, Dorothy Fuerstenau, and Herman Fuerstenau; (third row) Roy Fuerstenau, Raymond Simmons, August Fuerstenau, Mary Fuerstenau Simmons, and Grace Simmons.

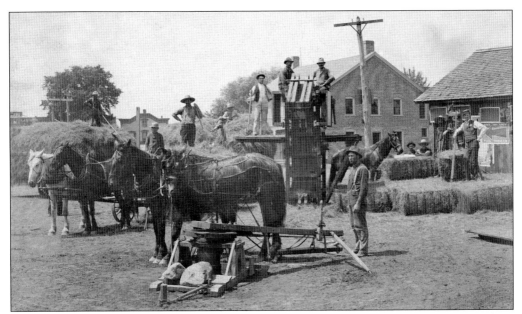

This July 3, 1913, photograph shows a two-horse pull-power hay press capable of pressing about eight tons per day. The building in the center is the Glenwood (Cook) Hotel. The photographer was D.D. Willert, who is the man standing on the far right. In 1890, the Lovejoy brothers handled about 100 railcars of pressed hay in a month.

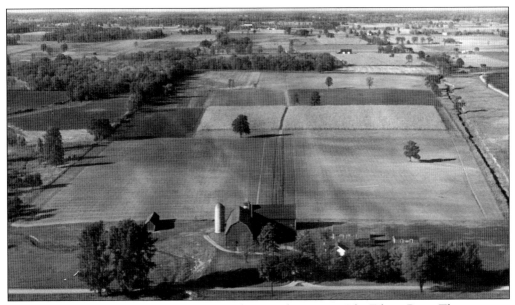

The first clearing made in Richmond Township was done in 1832 by Edwin Rose. The property, seen here, was then purchased in two parts in 1835 and 1837 by John and Irene Goodar. It is located on Clay Street (33 Mile Road). John's sons Francis and Hiram became owners of the land upon their father's death. The farm remained in the Goodar family for over 100 years. Hiram's daughter-in-law Lulu Hall Goodar was a granddaughter of Daniel Hall, the first settler on Memphis Ridge.

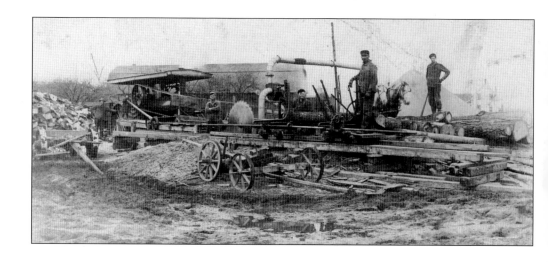

Joe Brandel (1860–1944) had a large farm along the west side of Main Street just north of Muttonville. In the c. 1900 photograph below, he is shown operating a steam-powered tractor to pull a five bottom plow. The round cylinders are weights that help push the plow blades into the ground instead of a hydraulic system. A farmer had to walk eight miles per acre to plow his fields with a walking plow, at the average speed of one and half miles per hour. The tractor and plow below was a real labor-saving machine. This same tractor is being used above to supply power to his sawmill. He also conducted a threshing outfit that threshed grain for several farms.

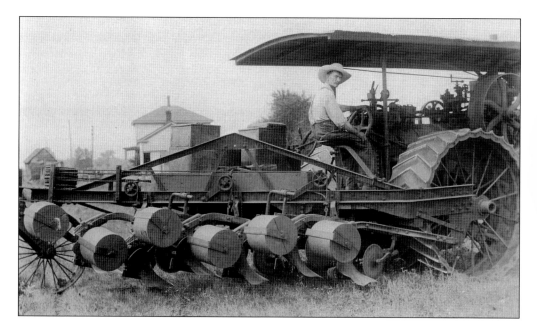

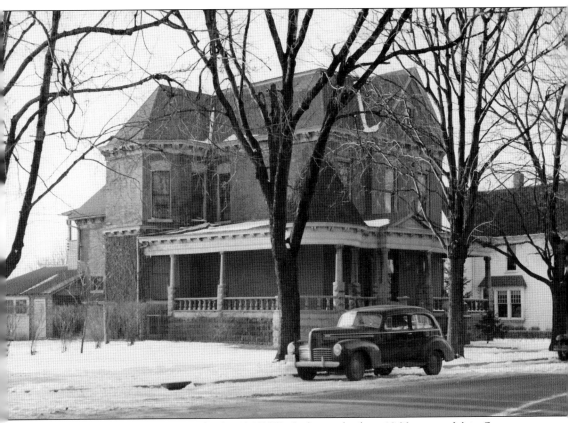

The Ira (1854–1923) and Lucy Vogt (1854–1940) Weeks home, built in 1866, was on Main Street, just north of Water Street. Ira Weeks was the son of David and Mary Weeks, who were originally from Vermont. After David and Mary were married in 1872, they made their home on Pound Road on a land grant that extended into Richmond and Columbus Townships. Ira and Lucy lived on a farm that was the family homestead on Pound Road until they moved into this house in 1903. Lucy was the daughter of John and Franzeska Vogt, Columbus pioneers who had come from Germany. Ira and Lucy had seven children: Cora (Heath) (1873–1981), Frederick (1874–1962), Melvin (1876–1956), Frances "Fanny" (Franklin) (1880–1908), Ira Raymond (1882–1959), Gertrude (Foster) (1886–1978), and Florence "Flossy" (Lindke) (1893–1975). Ira was a livestock dealer shipping stock to Detroit, Buffalo, and other large cities. Ira, his sons, and his grandsons were prominent businessmen in Richmond. In 1941, this house was torn down to make room for a theater and dairy bar.

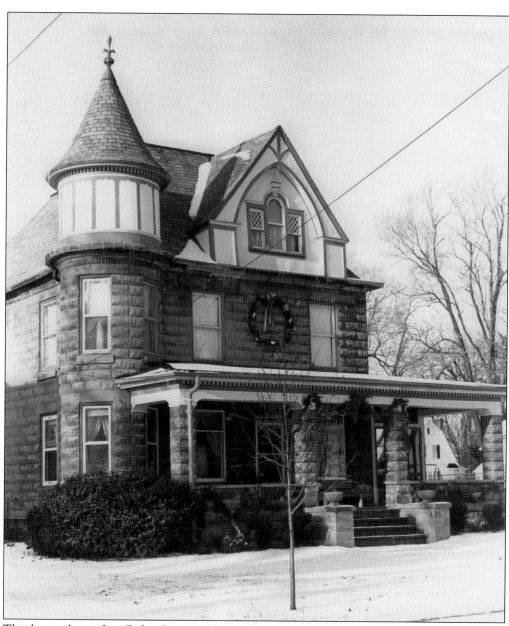

This house, located on Ridge Street at the Parker Street intersection, was known as the Weeks Castle. Melvin Weeks married Bertha Stuart of Richmond and had four children: Stuart, Florence Goodar, Marian Vernier, and Eleanor Moore. Weeks designed and built this Victorian-Queen Anne or Richardson-Romanesque–style home in 1900. Weeks cast the blocks used in the construction and hand carved the oak staircase. The Weeks family owned this house for over 60 years. A Richmond High School teacher occupied a tiny bedroom at the back of the home. A toilet and wash basin was installed there for her. Melvin went into the slaughter house business with his father and brothers until leaving to start the Richmond Petroleum Company in 1921. The company was extremely successful and distributed petroleum products in many communities in Macomb and St. Clair Counties. He sold the business in 1926 to the Indian Refining Company for a quarter of a million dollars. Melvin continued to manage the Richmond office.

Ray and Lola B. Weeks's home, seen below, was originally built by Alexander Heath in 1910. It was sold to Ray Weeks in 1921. This home is located on the west side of Main Street at Washington Street. Ray, pictured at right, started in the butchery business at 17 years of age with his father and brothers. He and his brothers built the first slaughter house, which was located along the Grand Trunk Line halfway between Pound and Division Roads. Ray's brothers moved on into other business ventures while he remained in the slaughterhouse business. Ray moved his business to a modern facility east of Grand Trunk Railroad at the north end of Howard Street in March 1948.

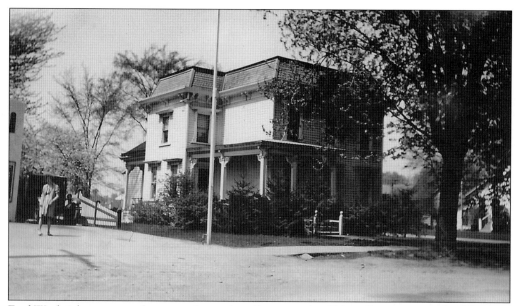

Fred Weeks's home, seen above, was located on the west side of Main Street just north of Division Avenue across from the former Weter-Fanning Egg Factory. Fred started his business, Feed and Grain, in 1925 in the old egg factory. He utilized only the south end of the building to begin with and then expanded into the entire building. He sold farm equipment, garden tractors, and lawn mowers as well as feeds and seeds. The basement, which formerly was used to store eggs, was used to store grain and potatoes. His two sons, Robert and David, were associated with him.

Fred Weeks was married to Verna Brown, who died in 1915. He later married her sister, Nina Brown, in 1918, and they had three children: David, Elaine Weinert, and Nina Potts.

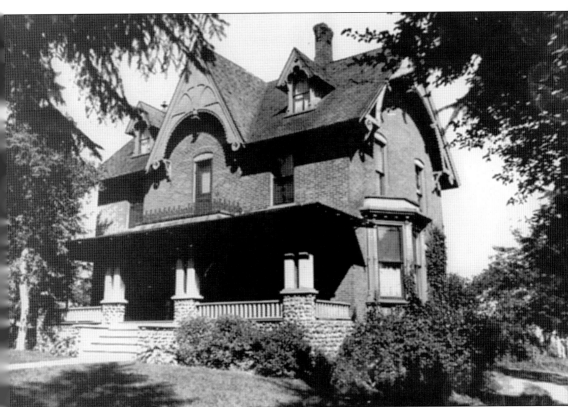

The Charles H. and Cora (Weeks) Heath home was located on the east side of Main Street, just north of Park Street. Charles Heath (1869–1937) was one of four children of Simon A. and Annis Ophelia (Beebe) Heath. Charles H. married Cora Weeks (1873–1964), daughter of Ira and Lucy Weeks, on May 10, 1899. They had three children: Milton, Marjorie Bingham, and Charles A. Charles H. Heath followed in his father's footsteps, serving as Richmond postmaster for about 18 years. After Charles's death in 1937, Cora ran a boardinghouse for local teachers and salesman with good references. In 1965, it was converted into a doctor's office by Dr. Patrick McCellan, who conducted his practice there for three years. The first floor had five examination rooms, and the kitchen on the back was converted into a procedure room. The upstairs held the doctor's private offices and medical library.

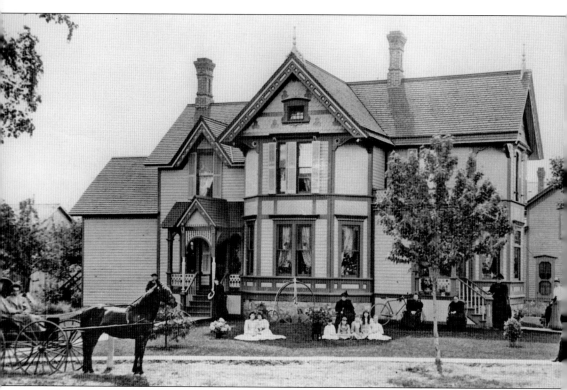

The George and Alice (Weeks) Bailey home is located at the corner of Park and Parker Streets in Richmond. This Victorian home was built in the late 1800s. Over the years, modifications were made to the home, including enlarging the side porch, making the woodshed into a kitchen, enlarging the dining room, and then adding on a woodshed. The woodshed was later turned into the furnace room at the back of the kitchen. George A. Bailey (1848–1903), son of Mahlon F. and Phoebe Cudworth Bailey, married Alice M. Weeks (1850–1917), daughter of David and Mary Weeks, in 1889. George worked for many years as a business agent for Portland Cement, traveling all over the country. Their son Elton D. Bailey (1877–1922) married Lettie Claggett (1879–1967), daughter of James and Jemima (Harmon) Claggett, Richmond pioneers, in 1901. The Claggett family came to this area in 1833 from New York State.

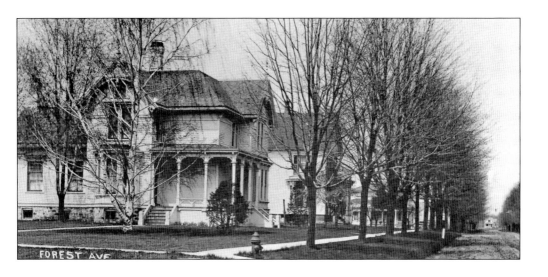

This home is located at the corner of North Forest and Division Streets. The house was once owned by Myron Cooley (1859–1901) and his wife, Edith M. (Martin) Cooley (1877–1971). Myron owned Cooley Brothers Richmond Agricultural Works, which produced farm implements. William H. Acker, president of William H. Acker Bank of Richmond, and his wife, Mary Clara (Gordon) Acker, also resided in this home. The Frank J. Hirt home below, seen around 1910, is located on the east side of North Main Street at Churchill Street. Frank J. Hirt (1870–1954) was the youngest of nine children of John A. and Elizabeth Hirt, German immigrants who settled in Casco Township. He owned the Richmond Review from 1895 to 1899. He was a cashier at Macomb County Savings Bank. In 1899, he married Bessie Simmons (1877–1948). The couple had four sons: Paul, Franz, Karl, and Gilbert.

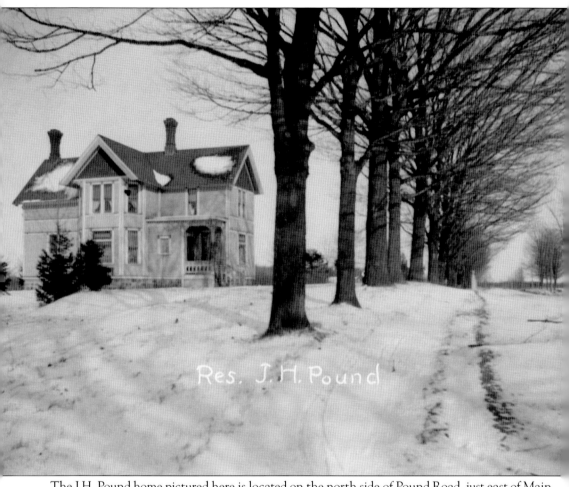

Res. J. H. Pound

The J.H. Pound home pictured here is located on the north side of Pound Road, just east of Main Street. J.H. Pound ran an icehouse across the pond that was north of this house. He owned a lot of acreage along Pound Road. It was purchased by Dr. Marie Rasey, psychologist, and Dr. Edith Hale Swift, pediatrician, in 1934 and became known as Rayswift. The first 10 years it was used as a summer retreat for researchers and educators. It later becoming a home for children, ages 4 to 14, with special needs, including learning and speech. The children would most likely stay, on average, two to three years. They provided a family-like living environment for the children who attended the public school system. It is now a private residence that has been extensively remodeled.

Nine

EVENTS AND
ORGANIZATIONS

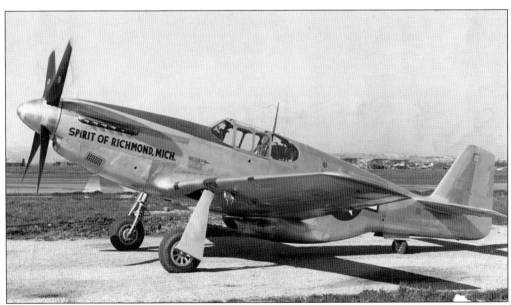

Richmond citizens purchased the *Spirit of Richmond* during World War II. National Bank president and general war loan drive chairman Albert Lindke led the drive. This was sponsored by the members of the Richmond Lions Club. They not only made their goal, but topped it. The end of this story is that apparently the plane above was used for publicity purposes and became the "Spirit of" every community that raised money to purchase planes.

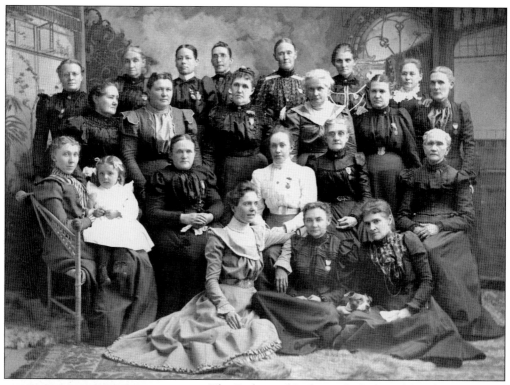

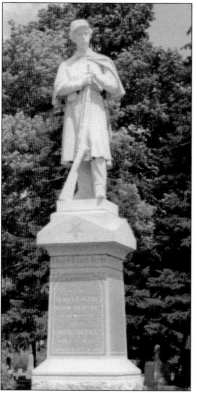

The Richmond Ladies Relief Corps (above) erected the statue of the Civil War soldier in the Richmond Cemetery as a memorial to Union soldiers. As an auxiliary of the Henry C. Beebe Grand Army of the Republic Post No. 223, they provided aid to disabled veterans, war widows, and orphans. They also worked on cemetery maintenance and the erection of war memorials. These groups were very active in the 1880s and 1890s. The memorial is located on what was the southwest corner of Daniel Hall's farm. The land for the cemetery was purchased from Hall in 1855.

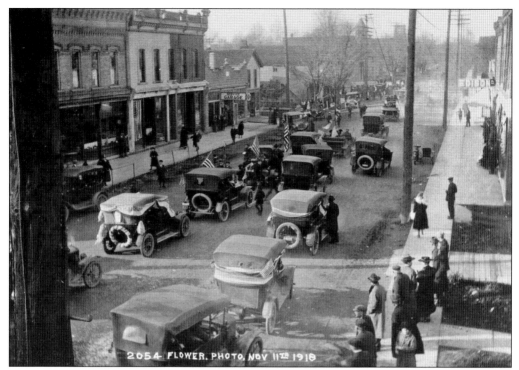

Residents celebrated the first Armistice Day on November 11, 1918, with a parade. Some of the residents that went off to fight in the Great War (World War I) were Scott Burke, Roy Fuerstenau, and Fred A. Schubert. This street view is from the southeast corner of Monroe and Main Streets looking north. Seen below, after the parade of automobiles, people gather around a flagpole that was located in the middle of the intersection. On the left is a band, and in the lower left is a flatbed truck that presumably was used as a speaker's stand.

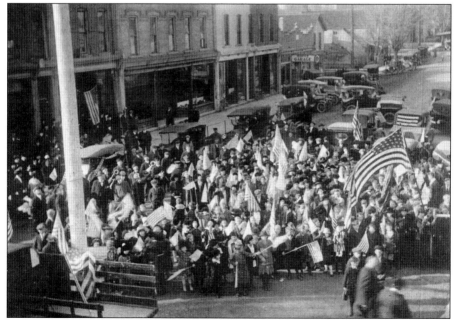

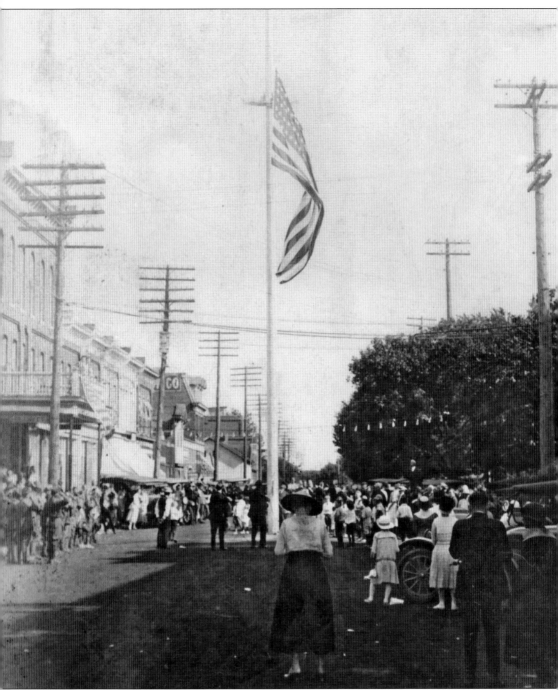

This three-story-tall flagpole was located in the intersection of Main and Monroe Streets looking south on Main Street. This flagpole was a utility pole painted white. It apparently was put up as a show of patriotism during World War I. On the left is a small group of soldiers saluting the flag. On the right is a man on a platform speaking to the crowd. This may be a Liberty Bond drive. *Richmond Review* articles during this time stressed the importance of supporting these drives, along with strongly encouraging women to volunteer to help the Red Cross.

This c. 1918 photograph shows a group of local Red Cross members. From left to right are (first row) Mrs. Merton Fuller, Mrs. Skinner, Mrs. Hensch, Anna Vogt, unidentified, and Mrs. Norton; (second row) two unidentified women, Anna Vogt, ? Fanning, three unidentified women, and Mrs. Burgess; (third row) four unidentified, David Carl, unidentified, Mrs. Welding, and Kitty Fulton. While most of the Red Cross effort was focused on the war, they also provided services to civilians at home, which primarily took the form of nursing activities and emergency response to natural disasters, such as the influenza pandemic that hit late in 1918. The *Richmond Review* during World War I pushed strongly for women to volunteer their services to the Red Cross.

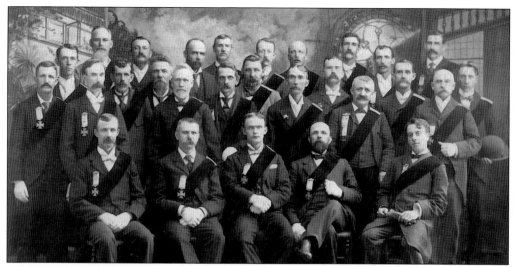

This is a photograph of Richmond's members of the International Order of the Foresters. From left to right are (first row) Shep Weter, Ira Heath, Bob Smith Jr., Charles Stoddard, and J. Thompson; (second row) Clayton Fuller, Frank Fanning, John Paterson, Al Kludt, Palmer Fuller, Charles Miller, John M. Johnson, Thomas Fanning, Willard Hale, Samuel Spore, Rob Randall, Thomas Leach, and Steve Stephenson; (third row) Henry Keller, ? Streeter, O. Culver, Dr. Black, Ira Lovejoy, John Keeler, Ira Hunt, George Weston, Henry Harman, and Robert Gould.

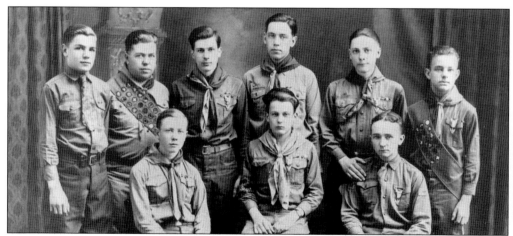

These Richmond area Boy Scouts had achieved the rank of Eagle Scout around 1928. This is the highest rank that a Boy Scout can achieve and is quite an accomplishment. The Boy Scouts of America (BSA) was incorporated by Chicago publisher William Boyce on February 8, 1910. From left to right are (first row) Maynard Hurlbut, Warren Weller, and Norbert Conlen; (second row) Phil O'Connell, Harold DeLano, Harold Weller, Gordon Ferguson, Malcalm Hurlbut, and Ken Rasmussen.

Central Park was located on the northeast corner of Main and Forest Streets. On Saturday evenings, the Richmond Band, led by Jesse Burroughs, played for area residents. The band was sponsored by the local businessmen until March 1925. The residents then voted to levy up to two mills "for the maintenance and employment, under municipal control, of a band for musical purposes for benefit of public." Village officers pledged to have the band play at Central Park. In 1962, this became the site of the Richmond Post Office.

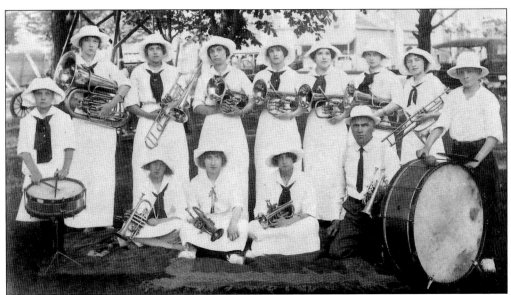

This photograph was taken of the Gierk Ladies Band in 1914 at a St. Peters Lutheran Church picnic. It was thought to be the only ladies band in the state. From left to right are, identified by their married names, (first row) Nadine Kohn Millett, Irene Foss Hansen, Agnes Bauman ?, Laura Gierk Dittman, bandleader William Gierk, and Harry Kohn; (second row) Elna Foss Fritz, Rena Gierk Locker, Agness Corbat Burke, Laura Trost Fillmore, Flossie Lapp Claggett, Esther Foss Trapp, and Ella Gauman ?.

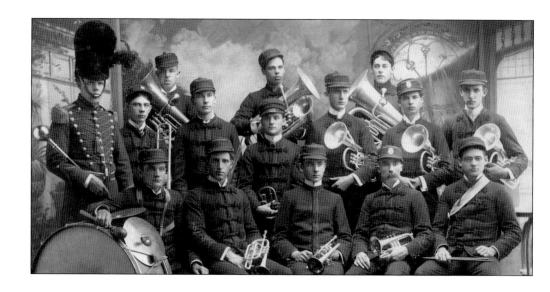

The Richmond Coronet Band is shown in the c. 1900 photograph above. From left to right are (first row) Charles Boutcher, Fred Weeks, Harry Cooper, Frank Fanning, and Elmer Sutton; (second row) drum major Warren Stone, James Oliver, Frank Hirt, Bert Miller, Roy Kirkham, Melvin Weeks, and Fred Weston; (third row) Otis Kohn, Charles Stutton, and Charlie Davidson. It is not known why the Village Band below is dressed in various costumes in this c. 1900 photograph.

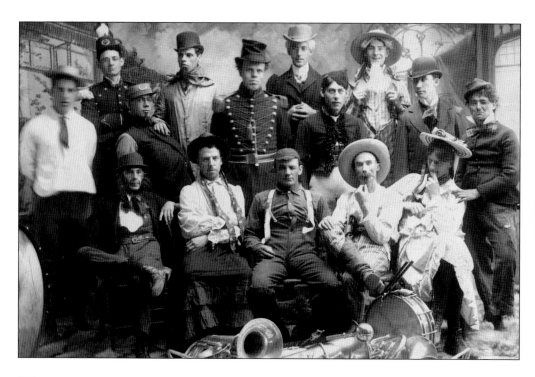

Good Old Days Festival Headquarters on Beebe Street and Festival Drive is seen as it appeared in 1983. This formerly was a horse barn that was next to a half-mile horse track where they had harness racing and later stock car racing. Today, this area is Beebe Street Park with baseball diamonds, swimming pool, community center, and picnic area.

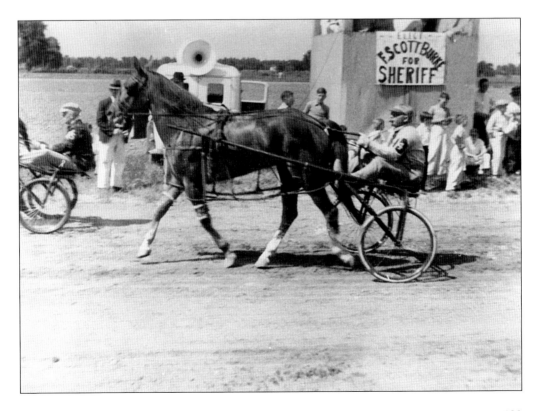

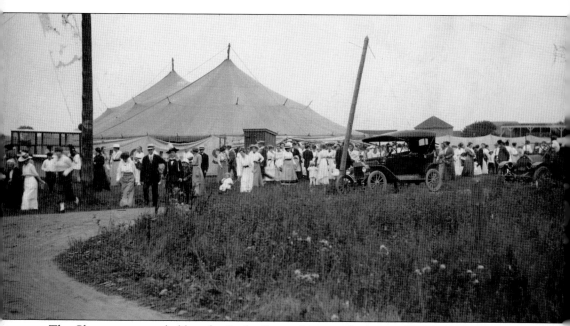

The Chautauqua was held at the Beebe Street fairgrounds August 20–24, 1914. Entertainment and lectures for the August event were well attended. Over 400 people attended the opening ceremony, growing to record-breaking crowds as the event progressed. An orchestra played popular and classical selections, and a 20-piece Italian band played classical, popular, and sacred music. The closing day brought a performance by Kirk Towns, a baritone soloist, and a presentation by Minnesota governor A.O. Eberhart on why the young men were leaving the country for city life and what could be done to stop that trend. Other performers throughout the weekend were an impersonator, a cartoonist, a magician, and a four-act play. Various lectures on a wide range of topics were also given. Weather throughout the five-day event was perfect.

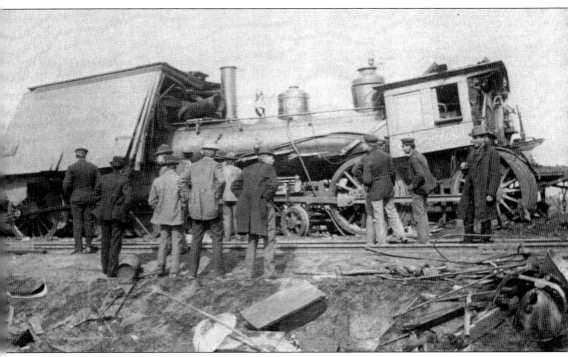

There were several train wrecks, such as the one above, that occurred in the Richmond area. One of these occurred between New Haven and Richmond on January 16, 1913, when a passenger train coming from Detroit collided with a freight train engine that had pulled out of a siding and stalled. Engineer John Cochran and fireman Charles Redunski of the passenger train were killed when, instead of jumping, they stayed at their posts trying desperately to stop the train. Both men were buried under the wreckage. John Cochran was found standing at his post with one hand on the reverse lever and the other on the air brake. Charles Redunski stayed in the cab to release sand on the rails to assist braking. Both men were described as heroes. Richmond residents who were passengers that suffered injuries were Ira Weeks, badly cut about the shins; Robert Allington, cut about the face; Mrs. Fred Weeks, bruised; Mrs. E.H. Rowley, several bad bruises; and Herman Dittmann, severely cut about the face and the loss of two teeth. Twenty-three passengers in all were injured.

The Richmond Area Historical and Genealogical Society is a nonprofit organization, established in January 1990. A group of citizens gathered in the Richmond Public Library with the common interest of preserving the 19th-century, one-room schoolhouse, which then sat in the middle of a cornfield in Richmond Township. The first building moved to Bailey Park was a Grand Trunk Railroad Depot built around 1921. It was donated by Joe Maranzano. Shortly after, in February 1994, the 1886 School Section Schoolhouse, donated by Jim McKiernan, was placed on site. A few years later, the Donley family donated a log cabin built by John Donley in 1850. The last building added to the "Historic Village" was the blacksmith shop/museum built by the society in 2009. The first floor houses a museum with rotating exhibits, and the basement and second floor are work and storage areas. Each of the buildings display period artifacts. The local schoolchildren use the schoolhouse for a daylong, late-19th-century school experience. The society is only successful due to the efforts of volunteers and the donations of contributors. New members and volunteers are welcome. Donations are tax deductible and can be made to: Richmond Area Historical and Genealogical Society, P.O. Box 68, Richmond, MI, 48062.

BIBLIOGRAPHY

Adamson, Ursula *Ursula's Genealogical Homepage.* Richmond Area Historical & Genealogical Society, 6 October 2010. http://www.richmondmihistory.org/Fanningdiaries.html

Beversdorf. *Sketches of Richmond.* Richmond, MI: Beversdorf, 1905.

Eldredge, Robert F. *Past and Present of Macomb County.* Chicago, IL: The S.J. Clarke Publishing Co., 1905.

Leeson, M. A. *History of Macomb County.* Chicago, IL: M.A. Leeson & Co., 1882.

Leonard, John William, editor. *Who's who in finance, banking, and insurance: A biographical dictionary of contemporary bankers, capitalists, and others engaged in financial activities in the United States and Canada.* Vol. 1. "Acker, William H." New York: Joseph & Seeton Publishers, 1911.

Lois Wagner Memorial Library Historic Photograph Collection. Vols. I thru VII. Richmond, MI: Lois Wagner Memorial Library.

Richmond Area Historical & Genealogical Society. *Richmond Review Collection, 1911–1951.* CD-ROM. Richmond, MI: RAHGS, 1911–1951.

Richmond High School Echo Staff. *Richmond Bicentennial History.* Richmond, MI: Richmond Bicentennial Committee, 1976.

Richmond Community Theatre. Richmond Community Theatre, 05 06. 2011. http://www.richmondtheatre.com

University of Iowa Libraries. (2007, October 4). "The Redpath Chautauqua Records 1890–1944". In *The Redpath Chautauqua Records 1890–1944, Special Collections and University Archives.*

DISCOVER THOUSANDS OF LOCAL HISTORY BOOKS FEATURING MILLIONS OF VINTAGE IMAGES

Arcadia Publishing, the leading local history publisher in the United States, is committed to making history accessible and meaningful through publishing books that celebrate and preserve the heritage of America's people and places.

Find more books like this at
www.arcadiapublishing.com

Search for your hometown history, your old stomping grounds, and even your favorite sports team.

Consistent with our mission to preserve history on a local level, this book was printed in South Carolina on American-made paper and manufactured entirely in the United States. Products carrying the accredited Forest Stewardship Council (FSC) label are printed on 100 percent FSC-certified paper.